Paydirt

Paydirt

The Spirit of Canadian Mining

PHOTOGRAPHY BY IONA WRIGHT • TEXT BY CHARLES PELLEY

The BOSTON
MILLS PRESS

ACKNOWLEDGMENTS

We wish to thank the following for their generous assistance to this project:
Kodak Canada Inc.; NAPPEG, The Association of Professional Engineers, Geologists and Geophysicists of the
Northwest Territories; Northwest Territories Arts Council; and we wish to extend our sincere gratitude to all the mines,
their management and employees who provided access to the worksites, participated in the photography, and who
throughout showed a high degree of professionalism and pride in mining.

CANADIAN CATALOGUING IN PUBLICATION DATA

Wright, Iona, 1954–
Paydirt : the spirit of Canadian mining

ISBN 1-55046-085-4

1. Mines and mineral resources - Canada - Pictorial works.
2. Mines and mineral resources - Canada - I. Pelley,
Charles. II. Title

TN26.W75 1996 622'-0971 c96-930700-4

Design by Gill Stead
Printed in HongKong by
Book Art Inc., Toronto

First published in 1996 by
THE BOSTON MILLS PRESS
132 Main Street
Erin, Ontario, Canada
N0B 1T0
Tel 519-833-2407
Fax 519-833-2195

An affiliate of
Stoddart Publishing Co. Limited
34 Lesmill Road
North York, Ontario, Canada
M3B 2T6

COVER PHOTOGRAPH: *Neil Corbett rides the pony down into the Phalen Colliery in Nova Scotia.*
The trolley car is lowered into the mine by means of a cable down an incline that reaches far out beneath the ocean floor.

BOSTON MILLS BOOKS are available for bulk purchase for sales promotions, premiums,
fundraising, and seminars. For details contact:

SPECIAL SALES DEPARTMENT, Stoddart Publishing Co. Limited, 34 Lesmill Road,
North York, Ontario, Canada M3B 2T6 Tel 416 445-3333 Fax 416 445-5967

To the spirit and courage
of all the men and women
in the Canadian mining industry

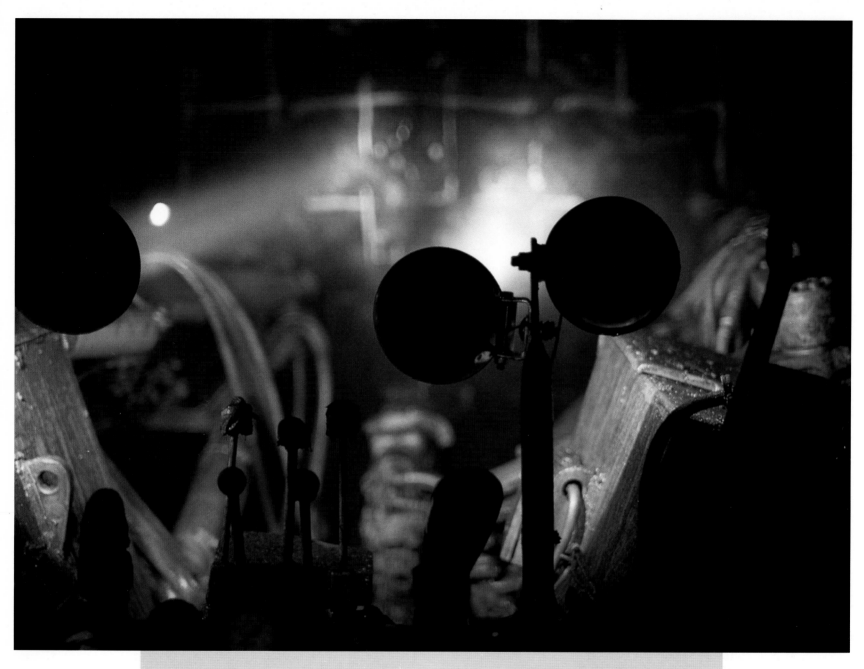

This drill jumbo operator at the Ruttan Mine in Leaf Rapids, Manitoba, guides his drills along the grid pattern drawn on the face of the tunnel. Each intersection marks where the holes are to be drilled. These holes will be loaded with explosives and then blasted to advance the tunnel.

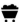

C O N T E N T S

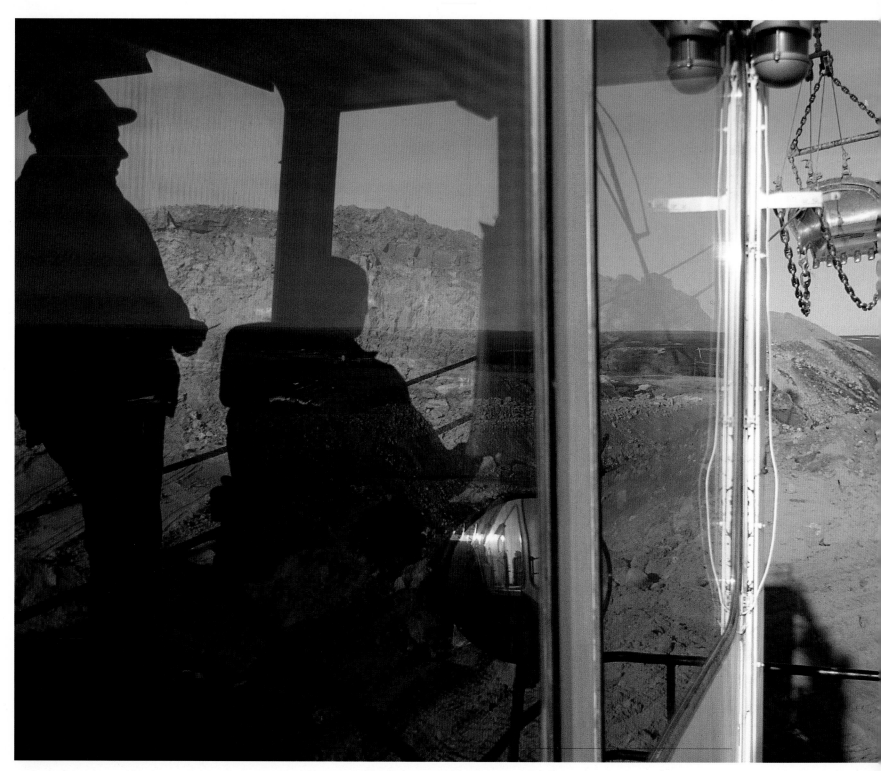

Team leader Mel Anderson joins dragline operator Al Kathrein.
Here they have a bird's-eye view of the operation around them. For an open-pit operation,
the Obed coal mine is considered quite small, employing only 125 people.

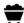

INTRODUCTION

The extraction of Canada's bountiful supply of mineral resources greatly enhanced the early development of this country. In addition to generating employment and wealth, the support of these mining activities added to the infrastructure of the country, particularly in developing critical transportation links to many remote locations.

The minerals industry continues to be an important contributor to the Canadian economy. Mining and metals fabricating activities generate over four percent of the Canadian Gross Domestic Product, with the actual mining and milling of the ores accounting for about one third of that total. In 1993, a time of very low metal prices, the value of primary Canadian minerals production declined to $14.9 billion. The value of metal production stood at $8.8 billion, down from a peak of $14 billion in 1989, with the highest-valued metals being gold, copper, zinc and nickel. The value of non-metal production was $1.9 billion, with potash, salt and asbestos being the most important products. The value of structural materials mined for the construction industry was $2.3 billion with coal contributing another $1.8 billion.

In 1992 world mineral markets, Canada ranked in the top five producers of some seventeen mineral commodities. We were the leading producer of potash, uranium, nickel and zinc and second in the production of sulphur, asbestos and cadmium. More importantly, however, Canada is a major exporter of many of these minerals, with $26 billion of minerals or mineral commodities exported in 1993 accounting for over fifteen percent of all Canadian exports. Though we imported some mineral commodities, we had a trade surplus of just over $10 billion. The leading importers of our mineral products were the United States, the European Economic Community, and Japan.

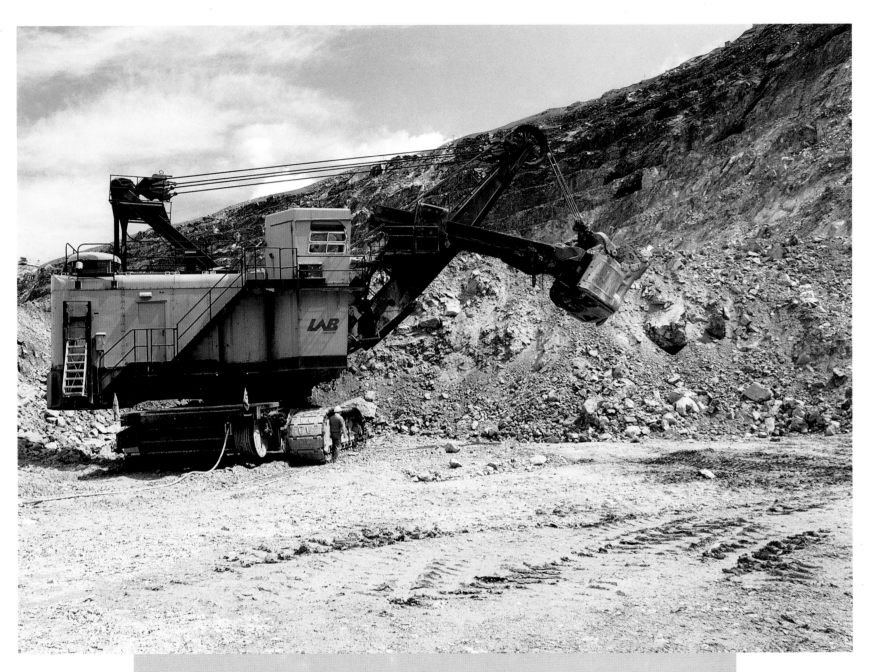

Three shovels keep the asbestos ore moving at the Black Lake Mine.
The public can view the pit from a station high above the mine site and just off the highway.

Canadian mining activity is spread over approximately five hundred mining operations in nine provinces and two territories, with Ontario, Quebec and British Columbia accounting for sixty-five percent of the entire mineral value. In 1993 there were about eighty-five thousand people directly employed in the mineral industry. While that represents a drop of about fifty thousand people since the peak in 1980, about half of that decline occurred during the recession of the early 1980s. The productivity increases brought about by new technologies and by well-trained employees have maintained the level of production and made Canada more competitive in the world marketplace. The average salary of mineral resource workers in this country partly reflects that high level of productivity. However, it also reflects the extra incentive required to attract workers to remote northern mining localities. According to Statistics Canada, the average 1993 wage of $912 per week was about $350 above the national industrial average and $200 higher than the second-place forestry industry.

Many more people are employed indirectly in minerals-industry-related activities such as transportation, equipment manufacturing and marketing. During the past decade, the international trade in crude and fabricated mineral products accounted for sixty to sixty-five percent of all tonnage handled in Canadian ports and the movement of those products provided between fifty-five and sixty percent of all freight revenue to Canadian railways.

These facts and figures, while underscoring the importance of the minerals industry to the overall economy, cannot portray the importance of mining to the people who work and live in the many isolated communities that depend almost exclusively on it. These communities provide a way of life in which parents can raise their families in relative safety and enjoy recreational facilities well beyond those available in similar-sized communities elsewhere. These people value the natural environment and work to ensure that modern environmental mining standards protect that environment. In certain localities, northern Saskatchewan for example, mining offers the only source of industrial employment to Native inhabitants and provides the training, both technical and managerial, necessary for the future economic development of those areas.

A familiar complaint of people who live and work in mining communities is that their industry is not understood or appreciated by those who live in the larger centres along the southern border of our country. Labrador City residents remember the hardships endured during the 1982–83 period when the Iron Ore Company of Canada went from twenty-seven hundred local employees to approximately sixteen hundred. While many industrial areas of the country suffered through the same recession, its effects in more diversified communities were often softened by expansion in other industries and by government activity. In Ottawa, for example, the expansion of both government employment and the information processing industry continued. I remember watching the parade of yachts on Big Rideau Lake one Friday afternoon in June as Ottawa residents "got away" for the weekend and wondering how legislators living in that environment could understand, and develop policy for, the people who were losing their jobs and homes in Labrador City.

When a writer from *Equinox*, an Ontario-based magazine, came to Labrador City in 1983, he was welcomed by both the community and company management, who hoped to better portray to the general public who we are and what we do. I remember my disappointment upon reading his mid-1984 article and finding our community described as the "godforsaken backyard of Labrador," and "a disgusting experience for anyone not raised there." In spite of the opportunity for photographs provided by the Iron Ore Company, which supplied the photographer with unrestricted use of a helicopter, the only two pictures included in the article were the front of a mine shovel and the side of one of the red buses used to transport the miners into the pits at shift change. From the air, he had even observed the annual 27-kilometre Labrador Loppet, a cross-country ski race from Fermont, Quebec, to Labrador City that brings together hundreds of people of all ages and occupations in a salute to the coming of spring. Those of us who lived in Labrador were shocked to read that "the very impossibility of life in Labrador held us there, hanging tenaciously to the end of the company whip."

It was in order to overcome many of these kinds of stereotypes that this book was supported

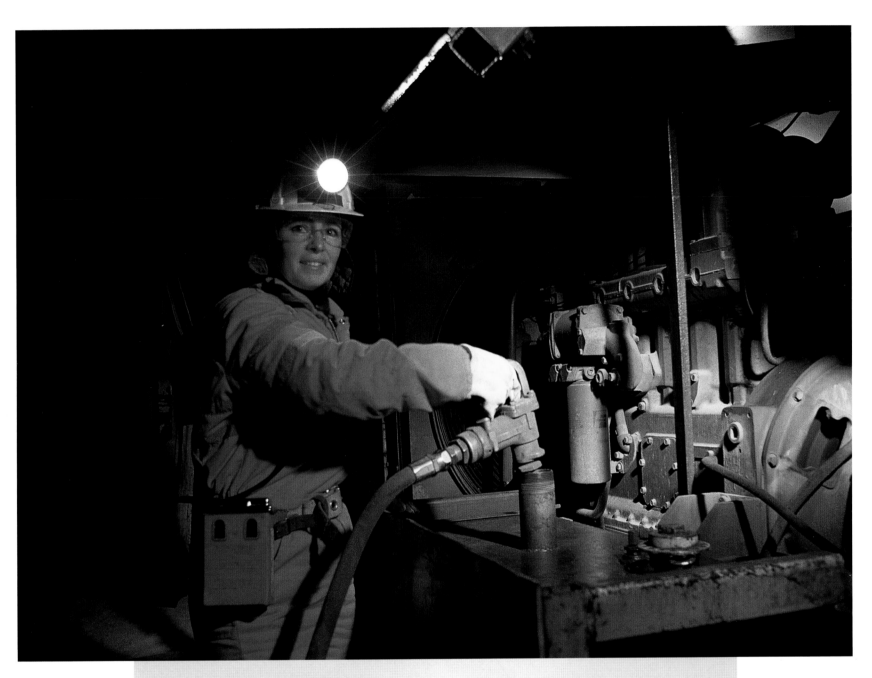

One of an increasing number of women now employed underground, Carmelita Halleran drives her diesel truck to work locations at the Polaris Mine checking fuel and oil levels of equipment.

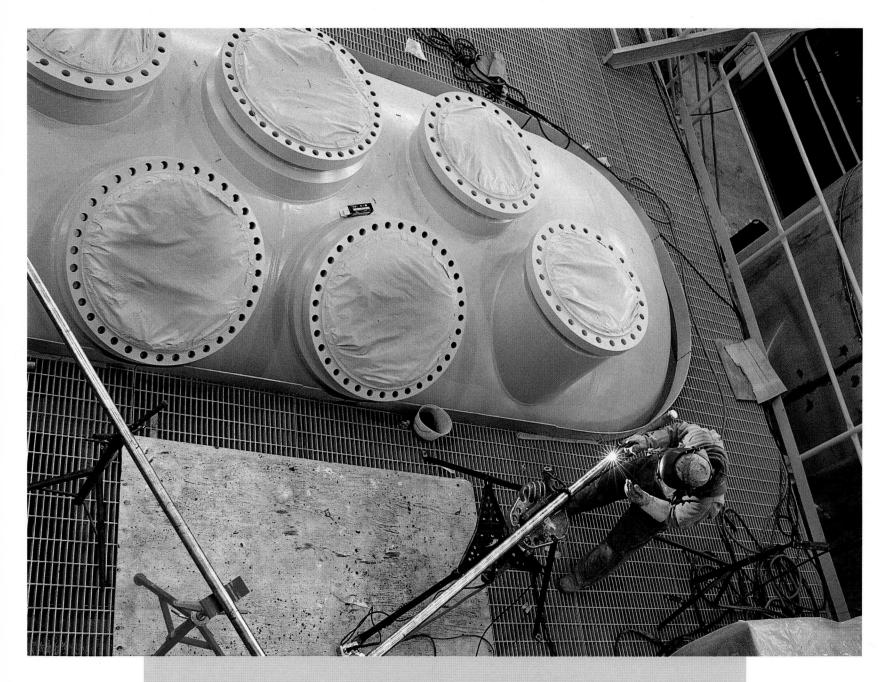

Autoclaves provide a clean and efficient means of recovering metals from ore.
Con Mine autoclave during construction.

so enthusiastically by mining companies across the country. They provided unrestricted access to their work sites. The support of the many supervisors who acted as guides and the people who appear in these photographs stems from a fierce pride of participation in the mining industry and from a desire that people outside the industry better understand it.

The Canadian mining community does not see mining as a sunset industry. It sees itself as making a valuable contribution to the Canadian economy. It sees its lifestyle as an independent one, not based on the continuance of the Canadian social safety net. The future of that lifestyle is, however, dependent on the ability to compete in the global marketplace. For various reasons Canadian mining companies are investing heavily in high-value orebodies in economically attractive foreign countries. To continue to attract investment in this country, the industry is demanding that the jurisdictional overlaps between the federal and provincial or territorial governments regarding environmental procedures be reduced. This would speed up project approval. Some environmental groups, on the other hand, are calling for a complete halt to mining development. These conflicting views must be dealt with before many Canadian mines can be developed. The Voisey's Bay deposit in Labrador, for example, a world-class nickel-copper-cobalt deposit, sits in an environmentally sensitive area on land occupied by Native groups with legitimate land claims. Its development must be based on sound environmental practices and provide social and economic benefits for the Native population.

A failure by governments, industry executives, aboriginal groups and environmental organizations to co-operate in resolving these kinds of issues could lead to a future decline in employment for the skilled workers of the Canadian mining industry. These workers and the jobs they carry out are portrayed in the photographs in this book. It is hoped that this portrayal will lead to a better understanding of the mining industry, its people, and its importance to Canada — maybe even to public support for legislative policies that will help to ensure its future. Observe them at work and learn why miners are so proud of what they do.

At the Arctic mine of Polaris, it is important to keep a watchful eye on ice conditions
as the ore can be transported only during the short open-water season.

DEVELOPMENT OF CANADIAN FRONTIERS

The first accounts of mineral-related activity in Canada begin with the arrival of the early European explorers. The Samuel Champlain expeditions discovered iron, silver and copper mineralization in Nova Scotia in 1604, and mining concessions were later granted by Louis XIV. Exports of coal to Boston are reported as early as 1724. As explorers worked their way westward, there were reports of iron deposits worked in Quebec by 1737 and of mineral discoveries at Lake Timiskaming by 1744 and the north shore of Lake Superior by 1770.

The history of larger-scale Canadian mining really begins with the California gold rush. The discovery of gold at Sutter's Mill in 1848 began a ten-year boom that generated $1.2 billion. As the boom diminished, many unsuccessful prospectors began looking for alternate opportunities. With the arrival of the Hudson's Bay Company steamer, *Otter*, in San Francisco in February 1858, carrying 800 ounces of gold discovered in the gravel bars of the lower Fraser River, the Cariboo gold rush was on. The British Columbia territory was then under lease by the HBC. The company's chief factor, James Douglas, was the governor. The HBC tried to control the influx of fortune seekers, even charging a toll of two dollars for every person transported to Yale at the head of the navigable section of the Fraser River.

Despite not finding any large quantities of gold, by the end of 1858 the most persistent gold seekers had reached the mouth of the Chilcotin River, about 560 kilometres inland. In the spring of 1859, Peter C. Dunlevy and his partners made the first major discovery in the Cariboo, along the Horsefly River. At the peak of the gold rush, Williams Creek, one of the

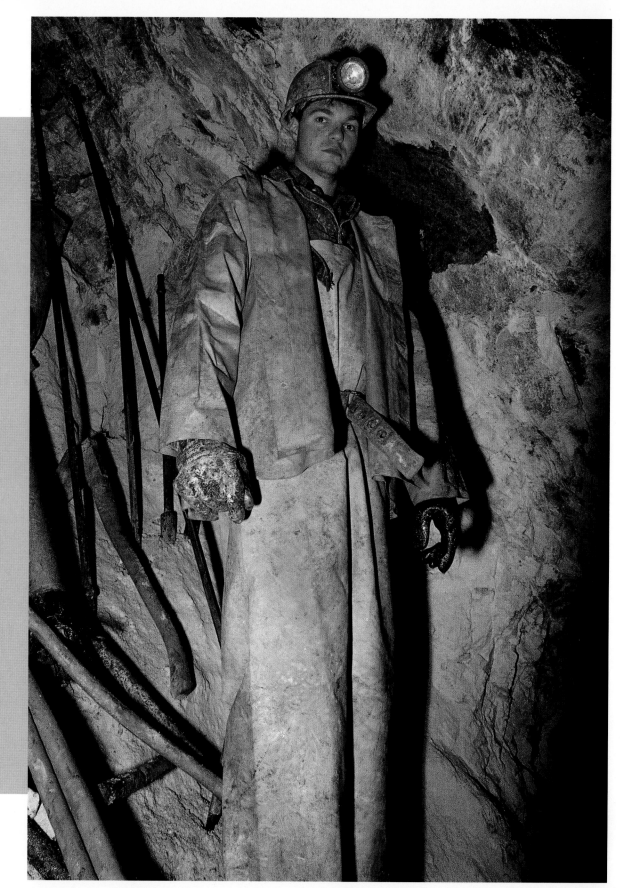

Mountain Minerals gave
Trevor Bolan a start in
the mining industry as a
miner's helper. It is his
job to ensure that all
necessary supplies are
available as the jackleg
operator needs them.

richest in the area, had as many as four thousand men working along a seven-mile stretch. One claim of 80 by 25 feet yielded gold worth over $100,000.

These riches supported the first mining-initiated development of Canadian infrastructure. Since the Cariboo was 800 kilometres from the navigable water at Yale, Governor Douglas, supported by a team of Royal Engineers sent out by the Colonial office in 1858, proposed a road from Yale to the area. The road, begun in 1862, was completed in three years at a cost of about $1.25 million. As the road was essential to the miners, Douglas initiated a system of tolls, which paid for the road before it was even completed. One entrepreneur, F. J. Bernard, started the British Columbia Express Company, a freighting company that in the first year of its operation carried fifteen hundred passengers and $4.5 million in gold. This company continued in operation until around 1910. While only $29.6 million is reported as having come from the Cariboo, the promise of more riches in the west was incentive enough for the people of Eastern Canada to push through a rail link.

Another portion of British Columbia was opened up from the South. The Kootenay area along the United States border was first explored in 1886 by a party from a Hudson's Bay post in Washington territory. Their expedition, although in search of gold, gave rise to the Silver King Mine, which produced silver and copper and established the town of Nelson. Production from these base-metal mines relied on access to a smelter in Butte, Montana. But increased mining activity in the Rossland area supported the need for a local smelter. F. Augustus Heinze, of the Montana Ore Purchasing Company, had a new one built at Trail Landing. It first produced in 1897. Heinze also developed various rail lines to assist in these mining operations. In 1898, his interests, including the smelter at Trail Landing, were purchased by the Canadian Pacific Railway for the sum of $800,000. This precluded the linking of the rail lines to the American lines to the south and greatly influenced the development of the Kootenay area as more investment began to come from Eastern Canada. The discovery of the Sullivan Mine in 1892 gave rise to the town of Kimberly. In 1909 the Sullivan Mine was leased to the Consolidated Mining and

Smelting Company of Canada Limited, a subsidiary of the C.P.R. Thus began the development of Cominco, one of Canada's major present-day mining companies.

The development of the railway to link Eastern Canada with the riches of the West led to the development of another major present-day Canadian mining area. As the C.P. R. pushed its line through Northern Ontario, a blacksmith named Tom Flanagan noticed highly stained rocks about five kilometres west of the newly established Sudbury station. He gathered some specimens, which were later appraised by the Geological Survey of Canada as containing copper sulphide of negligible economic value. While Flanagan did not register a claim, a claim was registered to Thomas and William Murray, merchants from Pembroke, and John Loughrin, a merchant and politician from Mattawa. The area later saw the establishment of the Murray Mine of INCO.

By 1900 all of the major INCO deposits that have since operated in the immediate Sudbury area were known. In 1901 Thomas Edison outlined the Falconbridge orebody by a dipneedle survey. He sank a shaft in overburden but failed to reach the orebody because of quicksand. It was finally uncovered after diamond drilling technology, which allows small sampling holes to be drilled through such overburden, was developed by E. J. Longyear around 1916.

The Cariboo and Klondike gold rushes did not require intensive capital investment to create wealth. All the prospectors needed was a claim and a gold pan or a sluice-box. The development of the Kootenay area depended on the availability of American smelters to the south for its initial cash flow. Two things were different in Sudbury. First, large sums of money were needed before development could begin. Second, the main economic metal was not gold or copper but a lesser-known metal called nickel. The initial development money came from Samuel J. Richie of Cleveland who formed the Canadian Copper Company in 1886 and began mining at the Frood, Stobie and Copper Cliff mines. Richie contracted to ship ore containing seven percent copper to the Orford Copper Company in New Jersey. But on its arrival the company's general manager, Robert Thompson, refused to accept it. The ore, in fact, contained only 4.5 percent copper and 2.5 percent nickel. No economic process existed at the

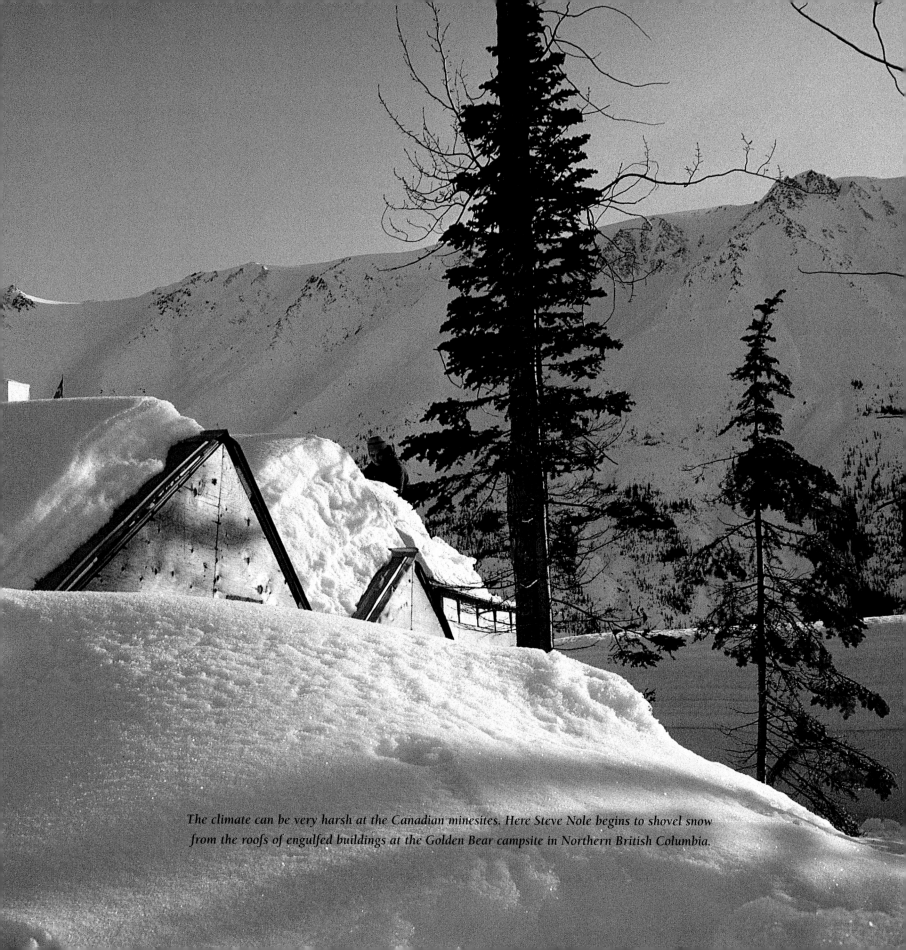

The climate can be very harsh at the Canadian minesites. Here Steve Nole begins to shovel snow from the roofs of engulfed buildings at the Golden Bear campsite in Northern British Columbia.

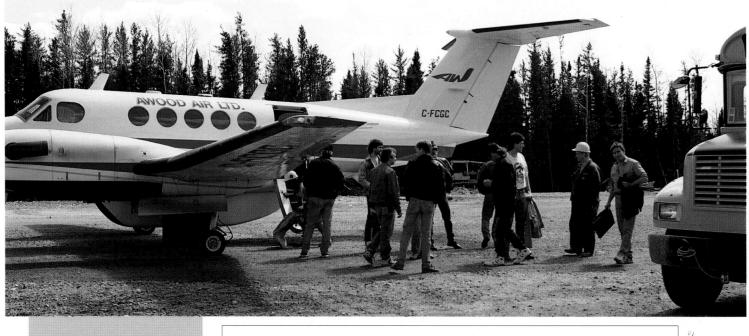

The crew arrives by plane at the Golden Patricia mine in Northern Ontario. Employees and supplies are flown in from Winnipeg, Thunder Bay and Dryden. During the winter, a winter road opens up and most supplies can be trucked in. They are met by a bus that will take them the remaining distance to the camp.

time to separate the nickel from the copper and the market for the product was limited. Richie was stuck with some one thousand tonnes, which sold at a dollar per pound, making it too expensive for general use.

Fortunately for Richie, Thompson developed a process for smelting nickel. Richie, meanwhile, developed markets by convincing French and British governments that nickel steel made better armour for warships. The process of roasting the ore was moved to Sudbury to eliminate the costs of transporting lower-grade raw ores to distant smelters. Unfortunately, this roasting process required cordwood and thus used up a lot of trees. In addition, the roasting process also released sulphur, which in turn would kill more trees, causing what was once the biggest environmental scar on the Canadian landscape.

While the development of the Sudbury nickel mines demonstrates the importance of innovation to the success of the mining industry, it is also an early lesson of the need for proper environmental assessment before new processes are introduced.

The building of yet another railway led to three major mining developments in Eastern Canada. The first began with the extension of a rail line from the C.P.R. line at North Bay to attract immigrants to the fertile clay belt along the upper Ottawa River. Another blacksmith, Fred LaRose, had noticed some pinkish cobalt bloom and staked claims on September 15, 1903, in the area that was to become Cobalt. LaRose sold half interest in his claims to the McMartins for $1,500 and left for a holiday in Hull. On his way through Mattawa he showed his specimens to Noah Timmins, who operated a general store in partnership with his brother Henry. They proceeded to buy twenty-five percent of LaRose's claims for $3,500.

On arriving in Cobalt, the Timmins brothers found that their new claims had been jumped. But a government-appointed land claims commission, meeting for three weeks, eventually awarded the claims to LaRose. LaRose, meanwhile, had sold his remaining twenty-five percent to the other owners for $25,000. By 1950, after much claim staking by many people, the resolution of many disputes, and the operation of many mines, the Cobalt area produced about 400 million ounces of silver and 18.6 million pounds of cobalt worth $250 million.

The railway was continued to Cochrane and prospectors advanced northward, inspired by the possibility of finding more mineral riches. One such prospector was Reuben D'Aigle, who had made a small fortune in placer gold in the Yukon and had taken a short course in mineralogy at Queen's University. It is likely that while at Queen's he had seen a report on quartz veins along Porcupine Lake in Northern Ontario. D'Aigle launched a major exploration effort at Porcupine Lake (he even brought in an anvil and a forge). D'Aigle was unsuccessful, but others followed him to the area. Harry Preston, upon slipping on a knoll, removed some of the moss covering a 6.5-metre vein containing free gold. That discovery eventually led to the establishment of the Dome Mine, which has been in continuous operation since 1911 and

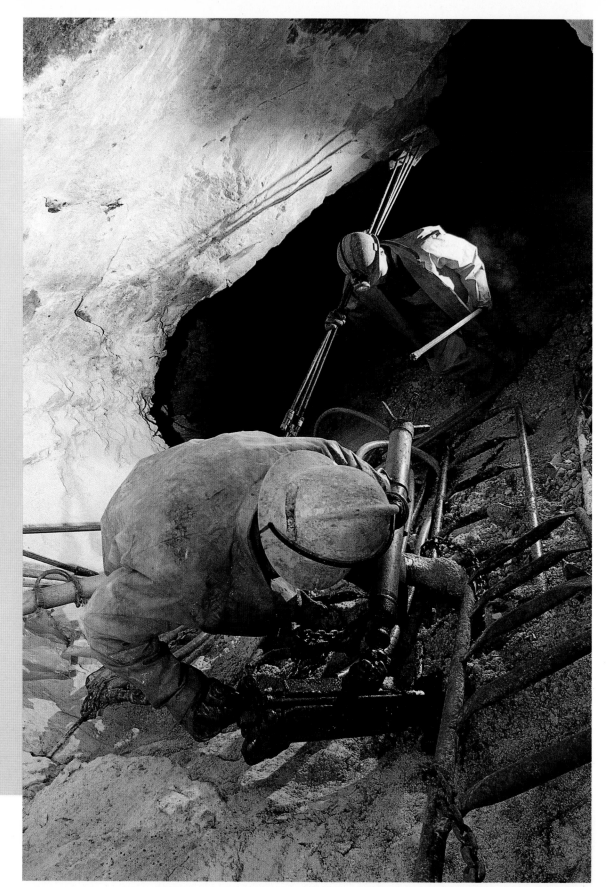

Sometimes getting a firm footing is not the easiest task. Here Germaine Villeneuve has worked his way up a steep incline with his jackleg drill. Below, his assistant, Trevor Bolen, waits with extra bolts.

which, in 1994, announced a major expansion to include an open-pit operation.

Based on news of that discovery, Benny Hollinger, a barber from Haileybury, and his partner were working their way westward when they discovered an abandoned pit containing D'Aigle's rusted anvil and forge. Nearby, Hollinger found a moss-covered vein of free gold, a metre wide and 18 metres long. After staking many claims in the area, Hollinger ended up with six claims for himself. Noah Timmins again entered the picture and, in 1909, with money accumulated from the Cobalt area, he bought Hollinger's claims, sight unseen, for $330,000.

While many other gold mines operated in the area, the Dome and Hollinger Mines acted as company-builders. Dome Mines Limited began in 1912 and acquired several notable mines, including the Campbell Red Lake Mine. In the mid-1980s the company merged with Placer to become Placer Dome and now operates mines worldwide. The Hollinger empire expanded in mining and energy production but has since become a major publishing group with newspaper operations in Canada, Great Britain and Australia under the direction of financier Conrad Black.

The third mining area developed in Eastern Canada was in the Labrador Trough. The initial work in this area was carried out by Reuben D'Aigle, who staked claims in the area as early as 1914, after having come so close to discovering the Hollinger deposit. One bay on Big Wabush Lake, near Labrador City, is in fact named for him. Partly due to D'Aigle's efforts, some Toronto financiers became interested in the area in 1929 and iron deposits were discovered. But a lack of interest by American steel companies saw the claims lapse.

The Labrador Mining and Exploration Company was formed in 1936, and under the direction of Dr. J. A. Retty, began exploration of its vast Labrador concessions from a base at Ashuanipi Lake, looking mainly for gold and base metals. Jules Timmins acquired control of that company in 1940, and with the formation of the Hollinger North Shore Exploration Company, which was granted concessions from Quebec, controlled concessions on both sides of the unrecognized border. George Humphrey, of the Hanna Mining Company of Cleveland, and Jules Timmins put together a deal with the American steel companies and the Quebec

government under Maurice Duplessis, which made development of the Schefferville area possible. The upper peninsula of Michigan and the iron range of Minnesota were starting to run out of direct-shipping ores and the pelletizing process for the taconite ores was not yet available. The steelmakers were thus eager to finance development of the area to assure a supply of ore for their blast furnaces.

What followed has been called one of the ten greatest engineering feats in Canada. The development of the port at Sept-Isles and the rail link to Schefferville along the Moise River to the Labrador Plateau were impressive in their own right. In order to ensure the production of ore by 1955, however, the facilities at Schefferville had to be ready when the rail line arrived. This gave rise to the largest civilian airlift to that time, surpassed only by the military airlift that supplied West Berlin during the Soviet blockade following the Second World War. Dozer-pulled trains were also used to bring in supplies on winter roads.

Electric power was supplied by dams: on the St. Margaret River for Sept Isles, on the Ashuanipi River for Schefferville, and later at Twin Falls for Labrador City. The development of the massive hydro-electric plant at Churchill Falls was greatly aided by the availability of this rail line. The mineral potential of the area remains underdeveloped.

There are many other examples of mining development in Canada. Iron mining began in Newfoundland with the development of the mines at Bell Island, and the Labrador mines continue to be important contributors to the provincial economy. The gypsum, salt and coal resources of Cape Breton supported fourteen mining operations in Nova Scotia in 1994. The base-metal deposits of the Bathurst area, the potash of Sussex, and one coal mine at Minto form the backbone of the New Brunswick mining industry.

Asbestos was first discovered in Quebec in 1860 and, at its peak, reserves of the mineral supported nine mining operations from Asbestos to East Broughton. Two major operations continue today. The discovery of the Horne Mine in Noranda led to the development of Noranda Incorporated, which now operates mines worldwide. With its control of

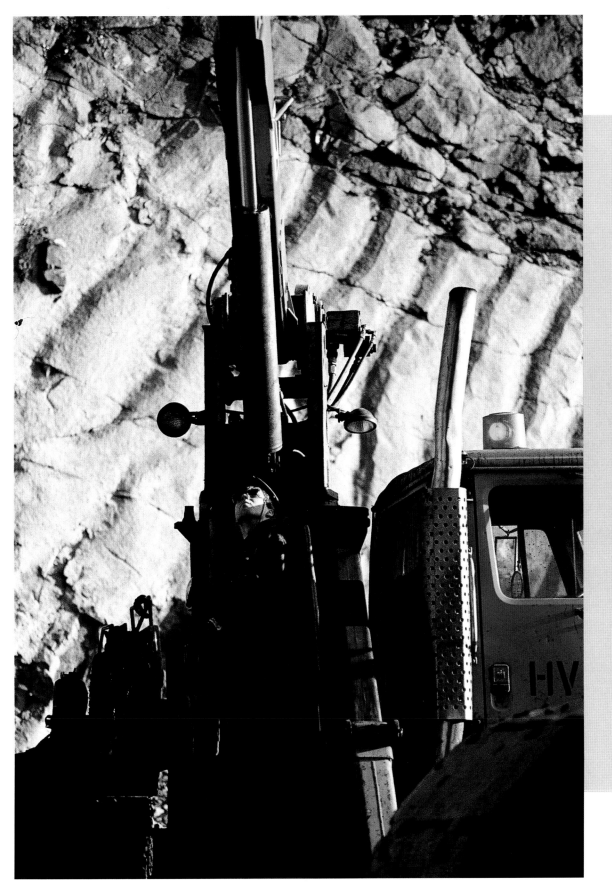

Darryl Hamblett looks on as the crane moves equipment at the Quintette Mine.

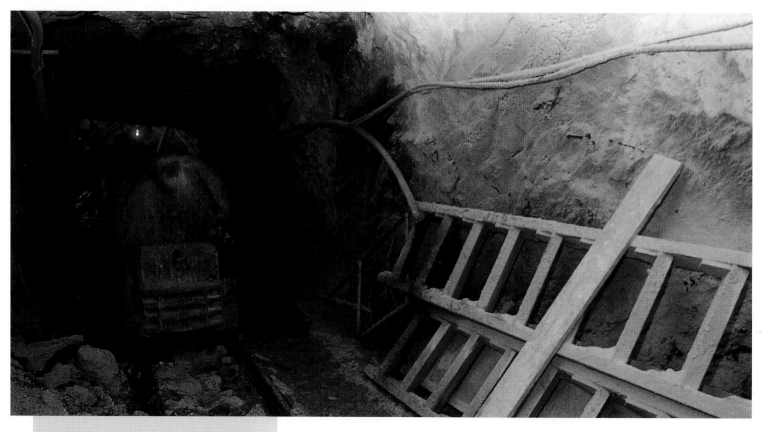

At Bakertalc Mine in Quebec, a small train was used to transport the ore from work areas to the skip bucket. Bakertalc is shown here in 1993, its last year of production after eighty-three years of operation. The mine was one of the shallower mines in Canada, reaching only 640 feet in depth. A small mine with few modern tools and equipment, it required only a handful of men to work, but the physical demands on these men were intense.

Falconbridge, it also operates smelters and refineries for copper, zinc and nickel in Quebec and Ontario. Quebec has a very active gold mining industry, with twenty-five mines operating in 1994.

In addition to Sudbury and Timmins, other major mining centres were developed in Ontario. The Elliot Lake uranium mines became major contributors to the economy in the early 1950s but mining activity there will cease in 1996. Several mines have operated in the Red Lake area and new, deeper reserves have assured the continuance of the two

operating mines. The discovery of the Hemlo orebody beneath the Trans-Canada Highway, 35 kilometres east of Marathon, gave rise to three major gold producers. Kirkland Lake has seen seven gold producers, with one still in operation. The salt and gypsum mines of Southern Ontario are also important economic contributors.

The notable mining operations in Manitoba are the Flin Flon operations of the Hudson Bay Mining and Smelting Company and the Thompson operations of INCO. In Saskatchewan the development of massive potash reserves has maintained Canada's role as an important world producer of the product. The very rich uranium reserves of the Athabasca Basin could see as many as six mines operating in the future, subject to world markets and environmental review. Coal production is a major contributor to the economies of Alberta and British Columbia, with the latter augmented by large porphyry copper deposits and by smaller gold and silver operations. The two gold producers in Yellowknife have been the mainstay of the mining industry in the Northwest Territories, but diamonds are likely to become a significant commodity in the near future. The economy of the Yukon has been dependent on the zinc deposits near Faro, which have gone through various closures and reopenings.

The development of all of these mining areas has required the overcoming of obstacles and uncertainties. New technologies for extraction and treatment of ores will be essential to the continued development of the mining industry. Companies such as Cominco, INCO, Placer Dome, Hollinger and Noranda, which are now multinational corporations, grew from these humble beginnings. Future mining developers will need a favourable economic and political climate in order to continue the growth of the Canadian mining industry.

*Many mining camps such as the Golden Bear complex shown here are built using portable trailer units
so that they can be easily relocated once ore reserves have been depleted.*

THE MINING COMMUNITY

It is difficult for many people to imagine what it is like to report daily to a workplace beneath the surface of the ground. Rita MacNeil's "Working Man," which she sings with the Men of the Deeps, stirs strong emotions in many of us who have regularly spent time underground. The lyrics describe a Cape Bretoner who is proud of his work in the mines but who swears to God that if he is successful he will never again return. And yet it is not uncommon to find third-generation miners in the coal mines of Cape Breton or Pictou County. These men have endured tragedies such as the 1992 Westray disaster, in which a coal-dust explosion killed twenty-six men. Who are these people and what is it about mining that makes them return to such a potentially hazardous working environment?

One inescapable fact about mining is that orebodies are usually found in remote locations. Mining operations are scattered from Hope Brook, Newfoundland, to Campbell River, British Columbia, and from Windsor, Ontario, to Nanisivik on Baffin Island. Miners and their families, therefore, often live in communities distanced both geographically and culturally from the more populated centres along the southern border of our country. People from many parts of the world have moved to these mining communities, making them truly multicultural. These people work together through many religious, social, cultural and recreational groups to enhance the quality of life in their communities.

The mining industry is known for its colourful and individualistic people. Notorious are the "packsack" miners, a group of men who work for contractors during underground construction. These men earn very high salaries and will go anywhere a new mine is being

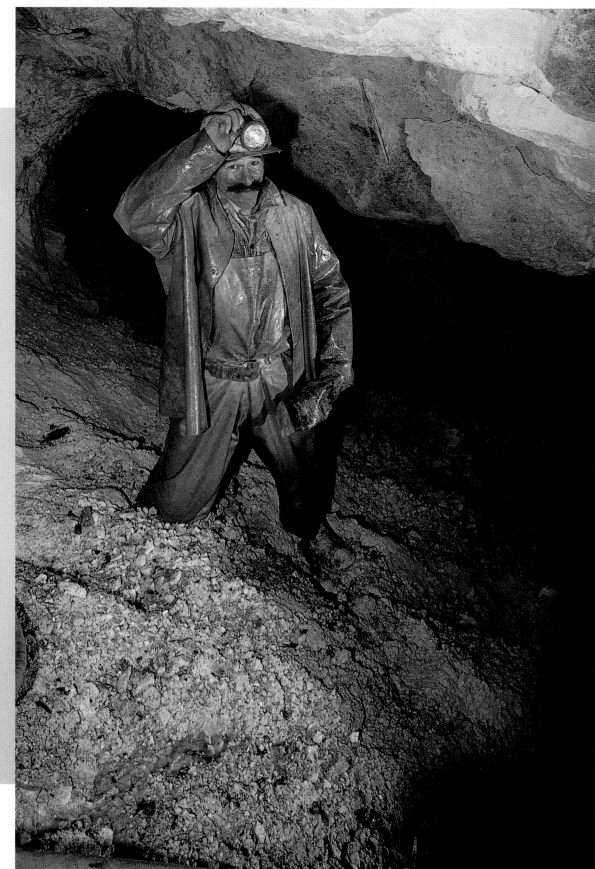

*Germaine Villeneuve
is one of Mountain Minerals'
most experienced miners.*

developed. I once met one such person who, at income tax time, had over forty T4 slips. He even had two for one day, having worked for one contractor on the day shift, then quit and worked for another on the afternoon shift. While these people may come from anywhere in Canada, there are some well-known places that turn out more than their share. One such location is Mabou, in Cape Breton. Here, John McIsaac, who was recently inducted into the Mining Hall of Fame, established his own mine-contracting business. Many people from the area have followed him into the mine development business and continue to do so today. Many others have come from the White Bay area of Newfoundland and from the Rouyn Noranda-Val d'Or area of Northern Quebec.

Cluff Lake has built an ultra-modern camp facility complete with apartment-style living quarters, gymnasium, recreation room, computer room and licenced lounge.

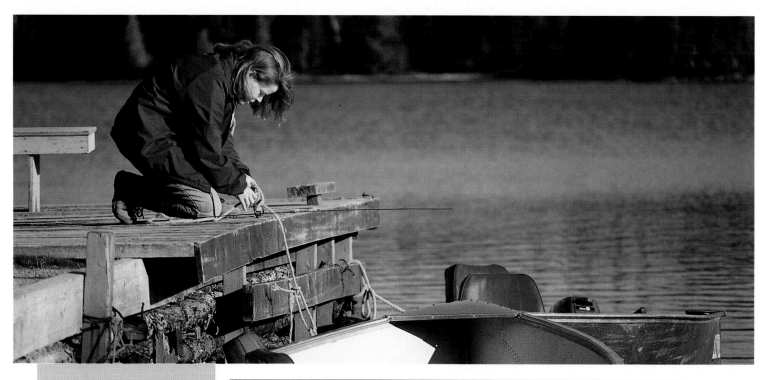

Janet Wishart, a geologist for the Golden Patricia Mine, spends a great deal of her time off out on the lake.

Newfoundlanders can be found in significant numbers in many mining towns across Canada. Lynn Lake, Manitoba; Fort McMurray, Alberta; and Manitouwadge, Ontario, all have a lot of Newfoundland expatriates — as many as twenty-five percent. Many of these people set out to find work during times of high unemployment on the island, with the intention of staying only as long as necessary and then returning to their native communities. But as their children have grown up and remained in the mining town, finding employment for themselves, many of these people have remained even after retirement.

Canadian mining towns have also attracted many European immigrants. In earlier times, immigrants came from Eastern Europe and the Baltic and Nordic states to escape the spread of communism and the ravages of the two world wars. Many found stable employment in

the developing northern towns of an expanding mining industry — the Finnish community of Sudbury for example. More recently, mining companies have actively recruited skilled tradespeople from areas such as Spain, Italy and Portugal.

The diversity of ancestral backgrounds present in Labrador City was proved very useful in 1983 when the town hosted a World Cup cross-country ski race. Athletes came from over twenty countries for the event. Race organizers had no difficulty recruiting volunteers to act as translators for the many different languages represented.

Successful industries depend on skilled and dedicated workers. The mining industry demands a high level of skills training and education. That level is increasing as mining and mineral-processing techniques become more advanced. In Ontario there is a common-core mining program that formalizes mining skills as a trade with training integrated within the community college system. The lucrative salaries offered by the industry often pull highly educated people away from their original career choices. Some years ago, I met an individual in the lunchroom of the Campbell Mine in Balmertown, Ontario, who had an education degree and a masters in history. He preferred mining since it provided better pay and the opportunity to travel.

Typically, life in remote resource-based towns is enhanced by a wide range of recreational opportunities. Mining companies often contribute to the construction of these recreational facilities either directly, through grants, or indirectly, through the provision of supplies and equipment. Many towns have full-size hockey rinks, and with a relatively long season for winter sports it is not surprising that a large number of professional hockey players have come from mining towns: the Mahovlich brothers from South Porcupine, Bobby Clarke from Flin Flon, George Armstrong from Falconbridge, and Gus Mortsen, Dick Duff, Ralph Backstrom, Daren Puppa and several others from Kirkland Lake.

Labrador City proudly boasts a professionally designed 15-kilometre cross-country ski trail, designed by Bill Koch, the first North American to win the World Cup in Nordic skiing.

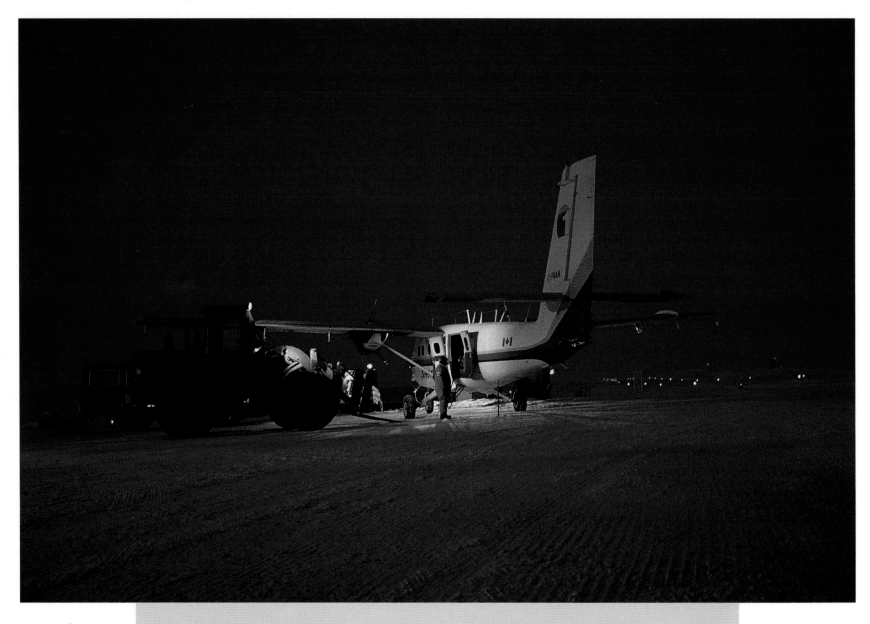

During the long winter months, this small plane is the only means of access to the Polaris mine on Little Cornwallis Island. The trip north takes one hour and twenty minutes by plane from Resolute in the Northwest Territories. The airstrip has been cleared on the tundra a short distance from the main camp. As there are polar bears and arctic wolves in the area, a bus picks up men and supplies as they arrive and delivers them right to the camp. The average work rotation is nine weeks in and three weeks out.

Much of the financing for that facility came from major suppliers to the local mining companies. Both the Canadian and American Nordic teams routinely train at that facility in October and November, taking advantage of the earliest snow in North America.

In remote northern mining towns it is important that entire families enjoy and participate in winter sports or life can become quite dreary. On a sunny Saturday during the winter months, when the thermometer may have risen to a balmy minus twenty degrees Celsius, the shops in town will be poorly attended as inhabitants take advantage of the invigorating outdoor life.

What distinguishes the people of a mining town from other Canadians? They are there by choice, in an area where both employment opportunities and rewards are high. They come from a rich diversity of cultural and ethnic backgrounds. They are often separated from close family and draw on friends and neighbors for support. They like to work hard and play hard. They are well educated and well travelled. The children growing up in a mining town are provided excellent schools and recreational facilities. The higher cost of food is offset by lower-than-normal housing costs (often company subsidized), and higher-than-average wages. In some cases, perks may include company housing, transportation to and from the workplace, and a yearly vacation subsidy. These people make a significant contribution to the Canadian economy, a contribution, it is hoped, that will continue.

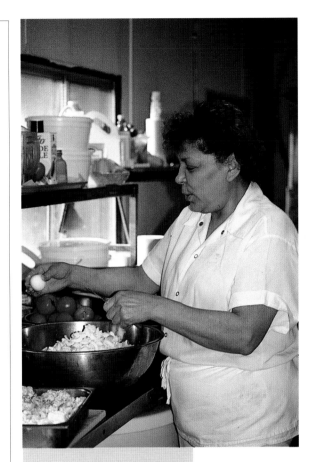

Mary Johnson is one of many cooks and assistants who prepare daily meals at the Cluff Lake Mine camp.

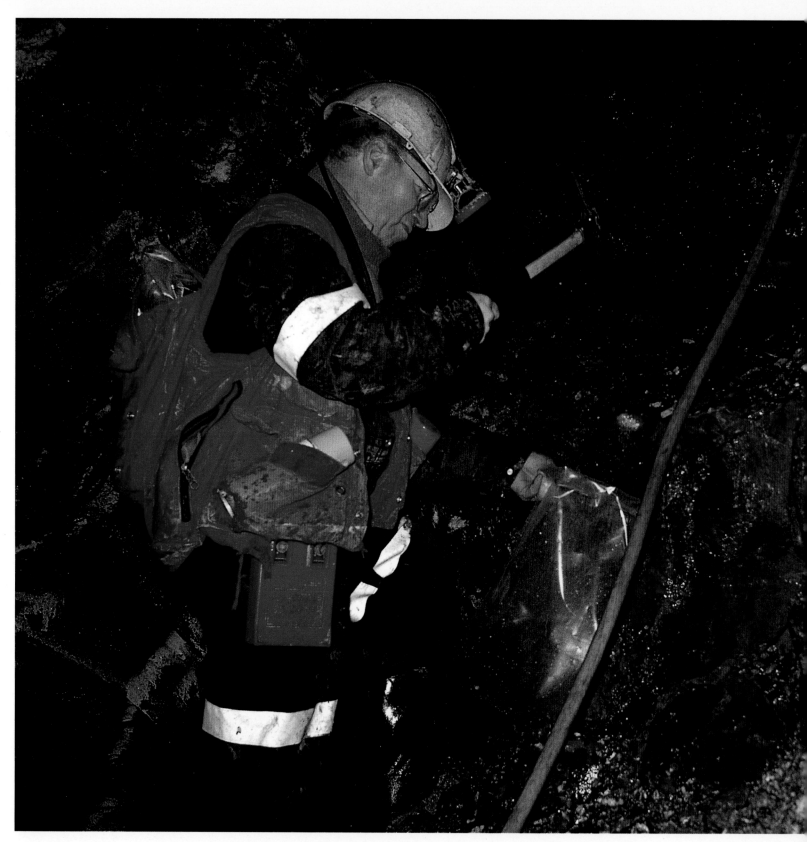

Geologist Alf Randall takes samples along new cuts of the Premier Gold Mine
to determine if enough ore is present to continue mining the area.

EXPLORATION

Mining requires the acceptance of risk. To replace its mineral inventory as rapidly as it is extracted is critical to the continued success of a mining company. Companies such as Northern Telecom and Microsoft are partly successful through heavy investment in research and development, which provide new products before old ones become obsolete or someone else learns to produce them more cheaply. The same is true for mining. It is hoped that the money spent on exploration by mining companies will result in new, larger and richer deposits that will enable them to compete in the world market.

Ore is a mineral occurrence present in such concentrations and volumes that it can be extracted and marketed at a profit. The first step of any mining operation is to explore, locate and evaluate such mineral occurrences. Anyone who has flown over the expanses of northern Canada can appreciate what it is like to see the short airstrip of Flin Flon or the gravel strip of Rabbit Lake suddenly appear out the window. It can be appropriately compared to finding a needle in a haystack. The odds of finding the ore deposit beneath all of that muskeg would not have been much better.

Early prospectors endured much hardship exploring uncharted wilderness; success was achieved with a little knowledge and a lot of luck. The first improvement in the life of the prospector came with the development of the float plane after the First World War. The Norseman, the Beaver and the Otter are among the well-known aircraft flown by the many pilots who returned from both world wars and adapted their newly acquired skills to exploring the North. This expanded the range of prospectors and enabled geologists and mapmakers to participate in the initial exploration efforts.

While exploration in remote areas remains expensive, both federal and provincial governments now share in that cost by providing the air photographs, topographic maps and regional geological maps required as the basis of any exploration program. Having had the opportunity to evaluate a phosphate deposit in Tanzania, where this type of support was not provided, I can appreciate this government involvement. Provincial geological surveyors carry out detailed geological, geophysical and geochemical surveys and release the results to the various interested mining companies. For example, a radioactivity survey of several regions of Labrador was released by the Government of Newfoundland at its annual November meeting in the late 1970s. That meeting was attended by the senior geologist of the Iron Ore Company of Canada who had a helicopter standing by in Schefferville. On being shown a radioactive anomaly from a lake near the Quebec border some 250 kilometres northeast of Schefferville, the geologist dispatched the helicopter. This led to the discovery of the Strange Lake deposit, one of the largest undeveloped deposits of yttrium and heavy rare earths known to exist in the world. As demand for these space-age metals increases, this deposit may become commercially viable.

A great leap forward in exploration technology occurred with the development of both surface and airborne geophysical surveys. The presence of a large body of metallic minerals hidden beneath the surface will act as a conductor for induced electric currents and in this way can be detected by surface instruments. Large metallic bodies will also cause deflection and concentration of the Earth's magnetic field, which can be measured by airborne instruments. Even after the extensive exploration for gold that had already been carried out in the Timmins area, the use of geophysical methods still led to the discovery of the world-class Kidd Creek base-metal deposit. It lay hidden beneath a swamp next to an already intensely explored area. Investigation of a magnetic anomaly caused by millions of tonnes of dense sulphide minerals led to the discovery. Canadian companies have become world leaders in exploration technology and export their expertise to many areas of the world.

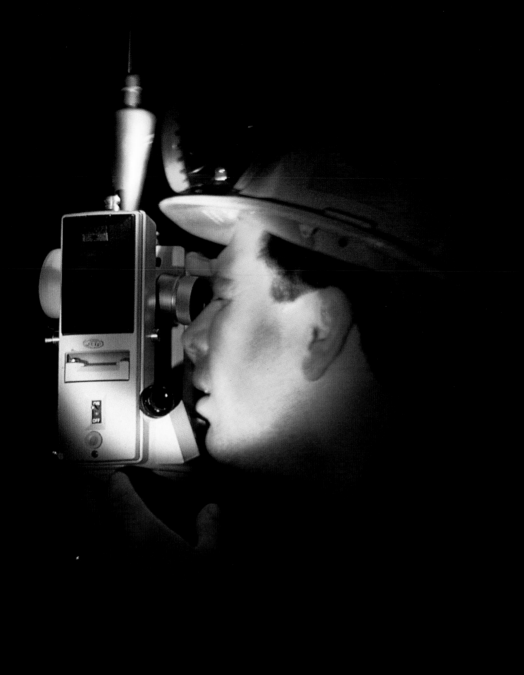

Chris Zorzi uses a theodolite to survey the mine drift at Algoma Steel.

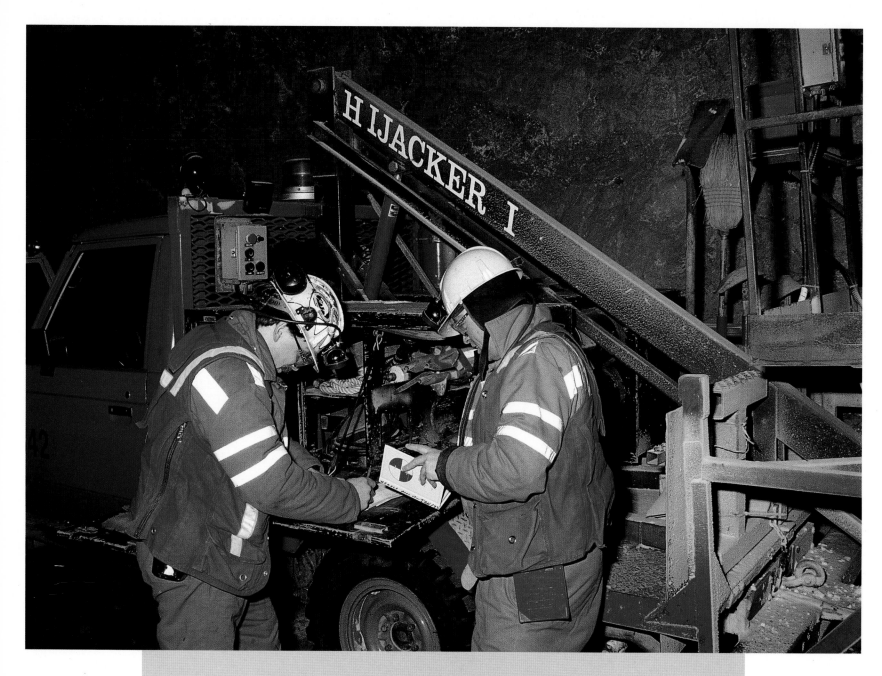

Polaris Mine engineers John Alma and Richard Gamache survey and map the area.

Some deposits, such as non-metallic ores and gold contained in quartz veins, are not amenable to geophysical exploration methods as they do not contain an adequate concentration of dense metallic minerals. These kinds of deposits can sometimes be located instead by mapping the concentrations of certain elements, in the overlying soil or lake sediments, that are commonly associated with metallic ore deposits. For example, the arsenic in the arsenopyrite commonly associated with gold may be the telltale indicator of a gold deposit. Even vegetation may indicate the anomalous presence of certain minerals. In Mediterranean countries, for example, figs are said to grow in areas of high-arsenic soils. Satellite imagery can now be used to detect subtle variations in soils and vegetation and identify possible exploration targets.

A regional survey or "greenfields exploration" is exploration carried out in remote unexplored areas of the country. Areas of high geological potential are chosen from regional geological maps. Availability of ground can be a limiting factor in exploration. Sometimes ground must be aquired from individual prospectors, who continue to roam the remote areas hoping to find the mother lode. The necessary expenditures increase with the intensity of the exploration effort. A geological team is required on the ground to carry out detailed mapping and sampling of any surface outcrops. In remote areas, this calls for airborne support. Once the exclusive domain of bush pilots, that task is now increasingly done by helicopter. Both means of transport are expensive and, unfortunately, even with the sophistication of today's exploration methods, most efforts wind up without success.

The next step in an exploration program involves the use of specialized equipment and personnel. Test holes are drilled to confirm or disprove projections based on geological evidence. The normal procedure is to remove a circular core of rock approximately 50 millimetres in diameter, using a cylindrical drill bit covered with diamonds. The special casing behind this bit delivers the core to the surface in 1.5-metre sections without the need to remove the drill rods, which advance the drill bit. Drilling costs depend on the type of rock and the remoteness of the location but usually begin at about a hundred dollars per metre. A test hole at the

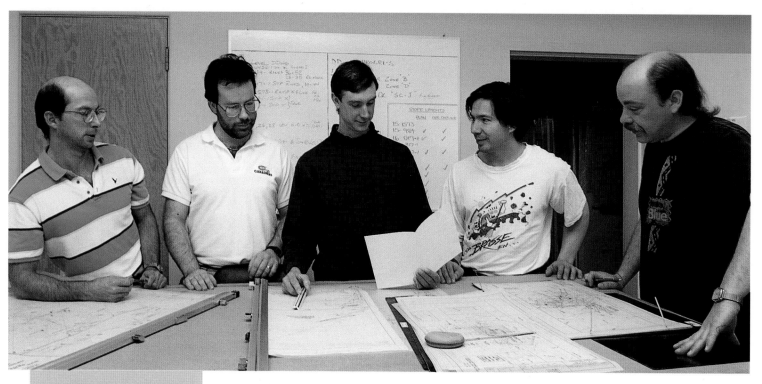

A team of engineers, geologists and technicians at the Arthur White Mine review data that has been collected to determine the most economical and viable mining plan.

Victor deposit of INCO Limited, which lies more than 2,500 metres below surface, cost over a million dollars to complete.

Test holes are normally drilled in a pre-established pattern. Even with what would be considered a very close drill pattern for the initial exploration stage, say at a 30-square-metre spacing, only 0.0002 percent of the orebody would be directly sampled. Considering the 50-millimetre core to be a representative sample of the 3-metre radius around the core, this still represents only three percent of the entire orebody. Electromagnetic geophysical techniques have been developed to detect the presence of magnetic anomalies (such as the dense sulphide minerals present in base-metal orebodies) within a few hundred metres of these boreholes. These

techniques are used to maximize the amount of information gathered from the very expensive deep test holes. Even with these advanced techniques, there are all too many documented cases where the initial reserves have been overestimated and efforts to develop the deposits have ended in economic failure.

Before committing the high level of funding required to develop a mine (from 100 to 300 million dollars), an exploration opening would normally be dug to provide an adequate sample of ore for metallurgical testing. This stage of exploration typically costs between 10 and 50 million dollars. For a shallow orebody, an inclined tunnel would suffice to allow access to the upper parts of the orebody. At the Eagle Point operation of Cameco, this stage involved a two-year program to develop a test mine to a depth of over 200 metres. At the same company's MacArthur River prospect this stage involved sinking an exploration shaft once environmental approval had been obtained.

Exploration is critical to the continued success of any mining company. It is also a very expensive and time-consuming process. It is not uncommon for ten years to elapse from the time a potential orebody is initially identified until actual production begins. Government agencies support exploration by providing the basic maps and geological information critical to the primary stages. Exploration is also supported by government taxation rules that allow Canadian exploration expenses to be deducted from earnings in the year in which they are incurred. In the past this was further enhanced by an extra one-third allowance for such risky expenditures, not unlike the favorable tax treatment still allowed for research and development expenditures. For junior companies, low-level government grants are available. There is also an allowance for investors to deduct exploration expenditures from personal income (although poor management of these funds by the mining industry has seen a severe restriction of such programs).

There has been an underinvestment in Canadian exploration in recent years, especially for base metals. Many Canadian companies have been investing abroad, most notably in Chile

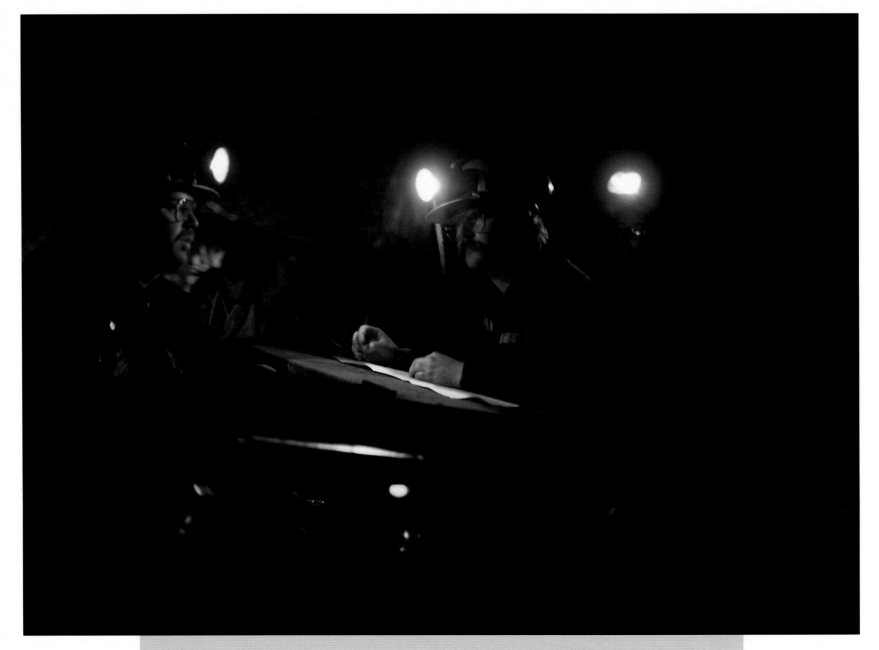

Geologists at the Arthur White Mine map the ore underground.

and other South American countries. There are several reasons for this. One reason is that there are many more readily available orebodies in these less-developed countries. Another is that the environmental approval process in these countries is usually much quicker (six months in Chile versus two years, minimum, in Canada). The main reason, though, is that large underexplored areas exist in these countries that do not require the costly exploration techniques necessary in Canada.

More local investment has occurred lately with the discovery of the Voisey's Bay deposit in Labrador. But for this investment to be sustainable and for the economic future of Canadian mining to remain viable, a commitment to the industry must must be made by the governing agencies to ensure consistent and well-defined taxation policies and environmental-permitting regulations.

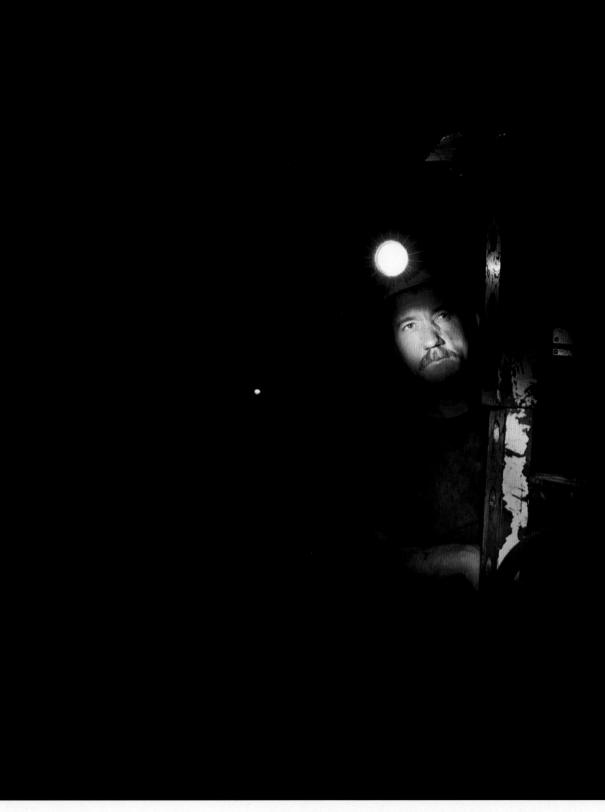

For coal miner Frank Conrad at the Phalen Colliery,
the only light to guide his mining machine is the one on his hard-hat.

MINE ACCESS AND SUPPLY

For someone who has never seen an underground mine, perhaps a good way to describe it is to compare it to a highrise office building. Like a highrise, an underground mine has an elevator (called a "cage") that brings workers to their respective levels and work stations (or "stopes"). The corridors of a mine are not as well lit as those of an office building. In a mine, light is provided only at the work stations and otherwise workers have to rely on the lamps attached to their hard-hats. In most highrise office buildings the windows cannot be opened. Ventilation is thus necessary to provide oxygen and to prevent the accumulation of toxic contaminants. The same is true in a mine, only here there are the additional contaminants produced by ore dust, explosives, and the operation of diesel-powered machinery.

In a large office building, thousands of people report to work daily but a relatively small amount of equipment is necessary to support their work. The opposite is true of a mine. In a mine, massive material support is required to sustain a small number of workers. The equipment required to carry out their activities and the fuel and maintenance items to support that equipment must be delivered to the workplace. Explosives are required to break the rock and reinforcing material is required to ensure the safety of the rock walls surrounding the mine openings.

A commonly heard question from a first-time visitor to an underground mine is, "Where are all the workers?" You can walk along ramps and levels for hundreds of metres without seeing anyone before finding one or two workers attending their machines. While there are

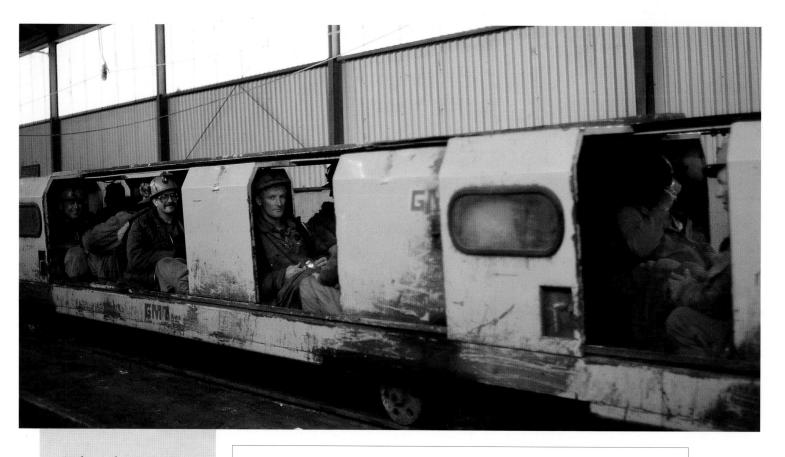

At the coal mines in Cape
Breton, Nova Scotia, the
men ride a pony-rail
system down into the mine.
Each compartment
holds four men.

still large labor-intensive gold mines in South Africa that employ as many as seventeen thousand personnel underground on a single day shift, most underground mines in Canada require a maximum of a few hundred personnel below surface at any one time.

While people who work in office buildings may do a lot of work, with the rise of computers, the physical output of that work is increasingly small. The bulk of the building's output can now be delivered electronically over data networks. Not so for mining. Here up to several thousand tonnes of ore produced by the operation must be hoisted to the surface daily for further upgrading.

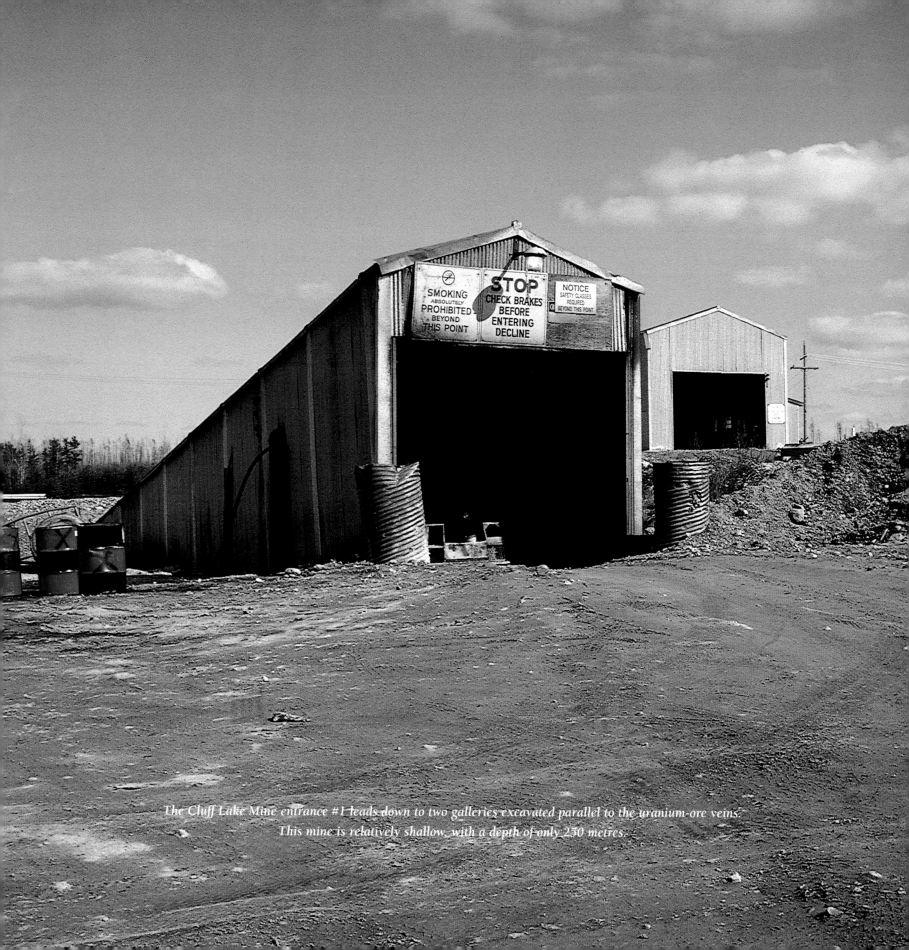

The signs on the building read:

SMOKING ABSOLUTELY **PROHIBITED** BEYOND **THIS POINT**

STOP CHECK BRAKES BEFORE ENTERING DECLINE

NOTICE SAFETY GLASSES REQUIRED BEYOND THIS POINT

The Cluff Lake Mine entrance #1 leads down to two galleries excavated parallel to the uranium-ore veins. This mine is relatively shallow, with a depth of only 230 metres.

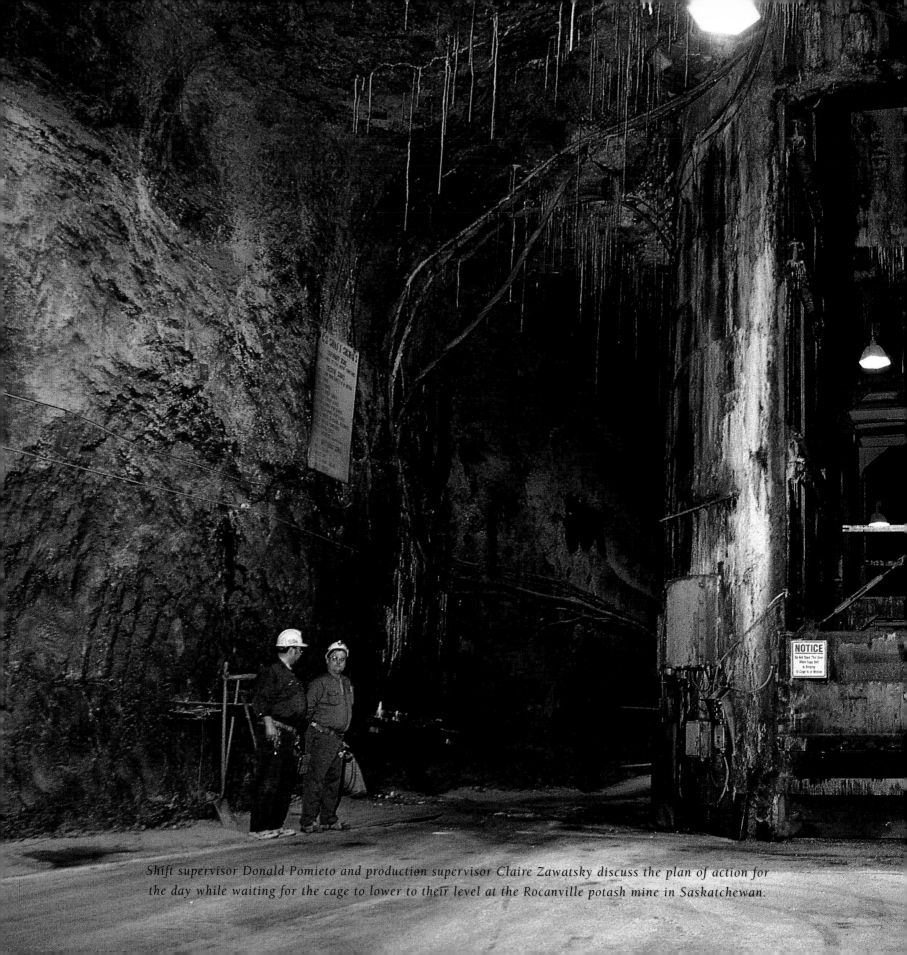

Shift supervisor Donald Pomieto and production supervisor Claire Zawatsky discuss the plan of action for the day while waiting for the cage to lower to their level at the Rocanville potash mine in Saskatchewan.

The vertical shaft is the lifeline of the underground mine. It is usually a 2-by-6-metre rectangular opening with three separate compartments. One compartment contains the cage, used to transport both personnel and supplies. The cage often has a bin on top (called a "skip") for hoisting ore. Attached to the cage is a single steel cable. The cable is wound onto a drum that is rotated by a large electric motor and extends over a sheave or pulley at the top of the shaft. The drum is operated by a hoistman who communicates with a person in the cage by means of a shaft signalling system. The second compartment contains the pipes and cables that deliver water, compressed air and electricity underground. The third compartment hosts a ladderway for

Enclosed in a soundproof room behind the hoist ropes, hoist operator John Moore, at the Lanigan Mine in Saskatchewan, is responsible for lowering the men and supplies to the underground stopes safely.

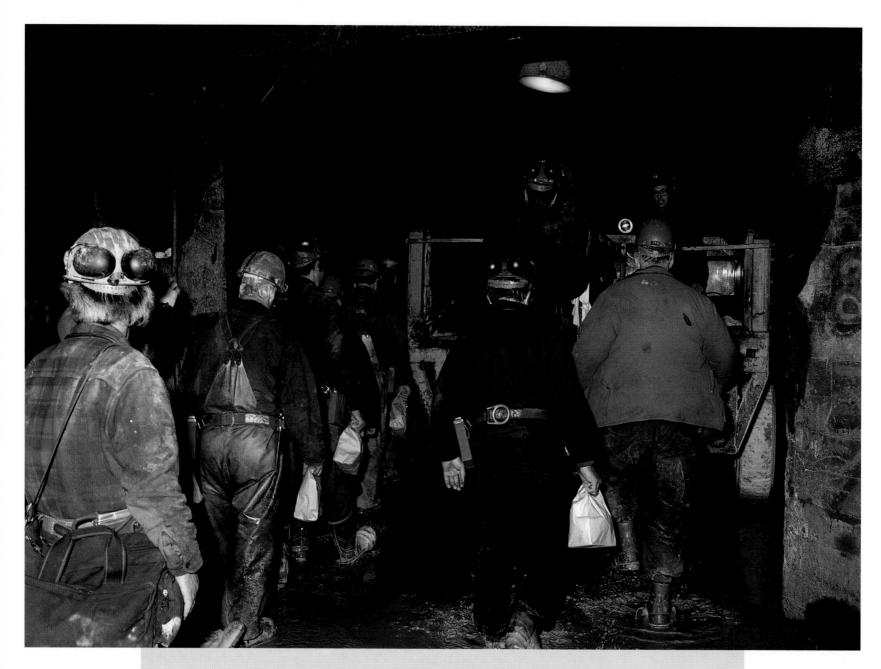

The miners at the Selbaie Mine on the way to their work levels.

To help younger members of the Brunswick mining crew adapt to the ride down into the mine,
the experienced miners will sometimes joke with them and tease them along the way.

emergency situations. With the help of fans, the entire shaft supplies fresh ventilating air underground. A second vertical opening is also required to allow the return of contaminated air and to act as a secondary emergency-exit route in case the main shaft is blocked.

At Kidd Creek Mines and Brunswick Mining and Smelting, large mining operations, the shafts are circular, over 8 metres in diameter, and lined with concrete. The individual compartments are constructed of structural steel. They contain two ore skips, each with counterweights to minimize the energy required to hoist the ore. These skips can travel as fast as 15 metres per second and can hoist up to 12,000 tonnes in a twenty-four-hour period. These shafts are also equipped with a large cage for personnel and materials, also with a counterweight. An auxiliary cage provides emergency back-up to the main cage. Multiple steel cables, for extra strength, rotate around a hoist drum at the top of the shaft. These conveyances are all automated and can be controlled as simply as a commercial elevator. The deepest shaft in Canada is sunk to a depth of over 2,180 metres.

By law, the cables in a mine shaft must have a capacity five times greater than the largest possible suspended load. In addition, pieces of the suspending cables must be removed on a regular basis and sent to a government test facility. If any loss of capacity is detected, the cable must be replaced. In Canadian mines, the cage travels along timber guide-rails. A spring-loaded gripping system, activated by any slack in the suspending cable, will grip the timber guide and stop the device. In many other parts of the world, mines are not equipped with this significant safety feature.

In a shallow mine, access may be provided by a decline- or sloping-tunnel system. Personnel and supplies are delivered underground by specialized equipment and the ore is removed by trucks. Beyond a few hundred metres of depth, these ramp systems are no longer competitive with vertical shafts for hoisting but they are still commonly used in conjunction with shafts to transport personnel and materials and to allow flexible movement of extraction equipment.

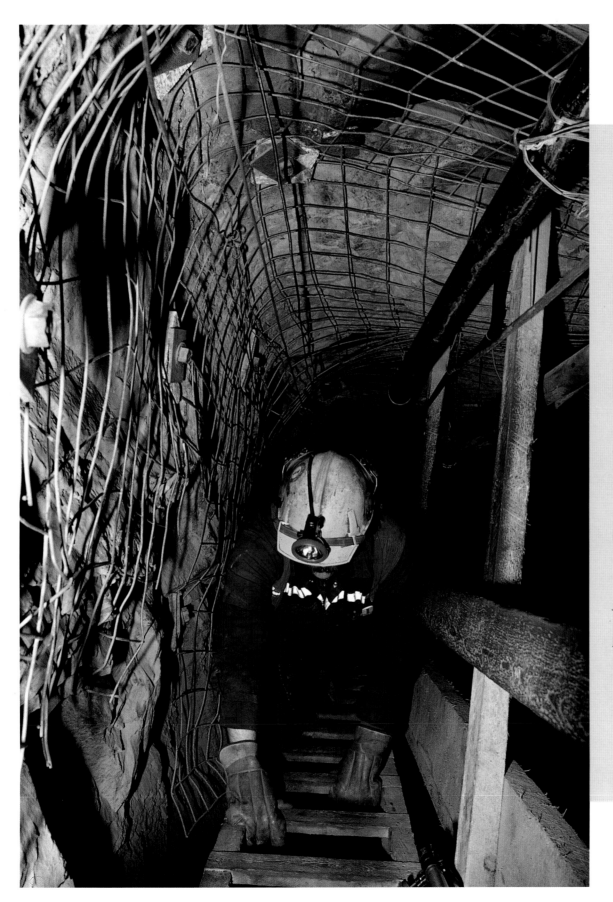

Underground mines are equipped with ladderways for use in case of emergency. At the Dickenson Mine in Balmerton, Ontario, the area surrounding the ladders has been completely enclosed with wire mesh and extra bolting to ensure that it remains a safe passage.

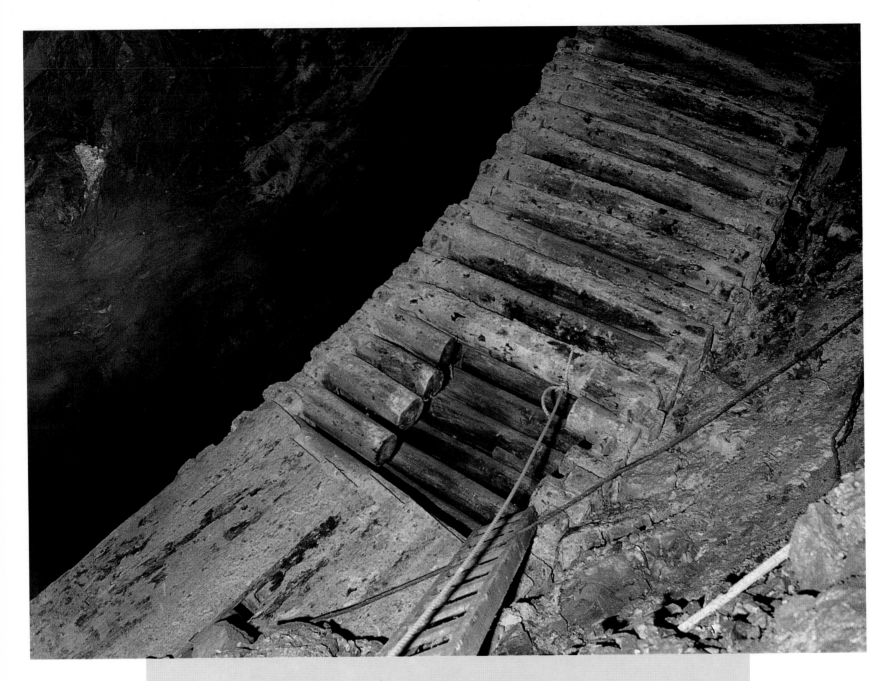

*To protect workers from falling rocks, ladderways are sometimes enclosed with timber
as shown here at the Premier Gold Mine.*

At many mines, including Kidd Creek, ramp systems have followed the progression of mining from surface to the bottom working levels. These ramps also serve as emergency escapeways and provide extra ventilation. Complex networks of horizontal tunnels are used for the distribution of personnel and supplies to the workplace. Since shafts are kept far enough from mining areas to protect them from damage by mining-induced rock stresses, the distance from the shaft to the orebody may exceed a kilometre in deeper mines. Orebodies are commonly in excess of one kilometre in length and are accessed on levels spaced from 25 to 100 metres apart vertically. This gives rise to many kilometres of access tunnels, varying in size from 3 by 3 metres in older tracked mines to 5 by 6 metres in larger mechanized mines. These tunnels also serve as conduits for air and water pipes and for drainage from the mining area. Rockbolts, wire mesh and sprayed cement (or "shotcrete") provide roof support.

In many mines, standard telephone systems are used to provide communication throughout this complex set of access ways. More recently, radio communications have been used for contact between mobile and fixed radio units. In today's high-tech mines, fibre optic systems are used to transmit the high levels of data generated by microseismic monitoring systems, fixed-equipment monitors on pumps or fans, and on-board diagnostic systems on mobile equipment.

Underground mines require access systems that allow the vertical and horizontal movement of personnel and goods to the workplace and the removal of the ore. Openings must be structurally sound and properly ventilated. The system requires adequate design and skilled workers as well as high-quality and well-maintained equipment to be successful. Considering the complexity of the operation, the very low incidence of serious injuries in mining is a tribute to the design engineers and the operating personnel who make mining operations successful.

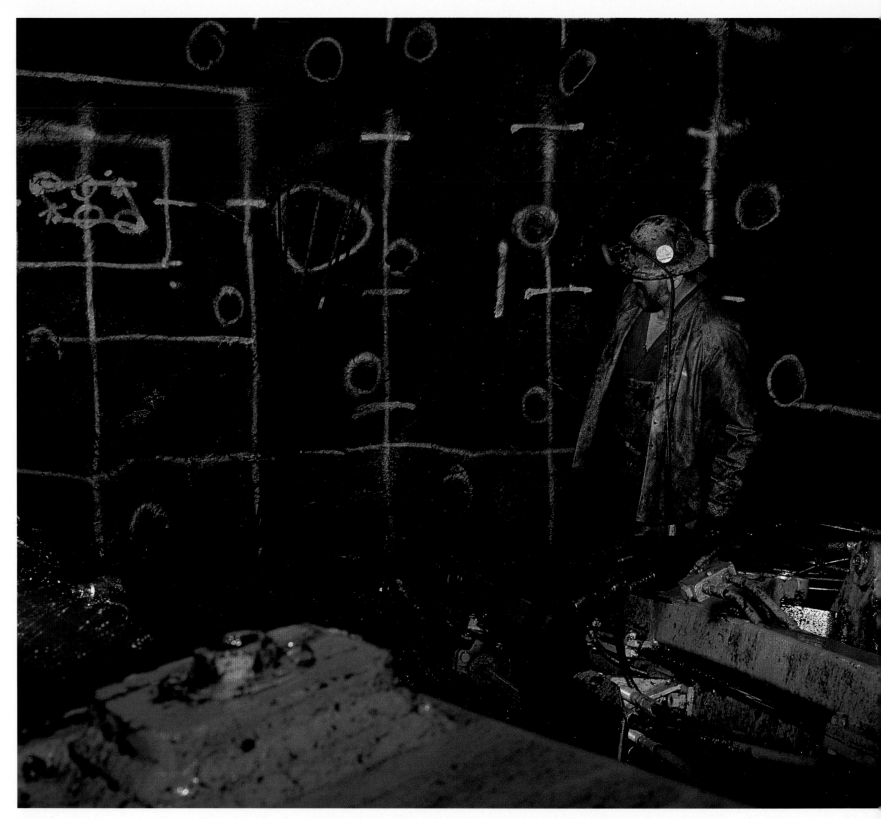

Ruttan's Nick Shaw has just finished painting the drill pattern on the face of the drift so that the drill jumbo operator will know where to drill the holes. Each face must be marked individually, as the miner must start each new hole at least six inches from the remnants of any previous blast holes.

THE UNDERGROUND MINING PROCESS

To better understand the activities that go on in an underground mine, one should know the various steps involved in the ore-extraction process. The first step, as outlined above, is to provide an opening for access to the stopes and to keep this access safe and secure as the extraction proceeds. The next step is to break the orebody by drilling blastholes throughout it, filling them with explosives, and initiating the blast in a controlled manner. The ore must then be removed along the access opening to be crushed and hoisted to surface. Finally, in most mining methods, the cavity created by removal of the ore must by filled to prevent ground movement, which could affect the removal of adjacent ore. The exact mining method used is dependent on the geometry of the orebody, the value of the ore, the strength of the ore and the host rock, and on the rock pressures encountered in the mine due to depth. The details of these methods are beyond the scope of this book and would take an understanding of many technical terms used in the industry. Instead, I have attempted to provide some basic insight into each step of the process, concentrating on the changes that have occurred during the past two decades to reduce labor intensity and to improve the safety of the miner.

The drilling of a blasthole began as a two-man operation, with one holding and rotating a steel bit and the other striking it. By the early 1900s miners were using hammer drills powered by compressed air. The drill bit has a series of pointed and hardened surfaces that cause small pieces of the rock to break away with each new blow.

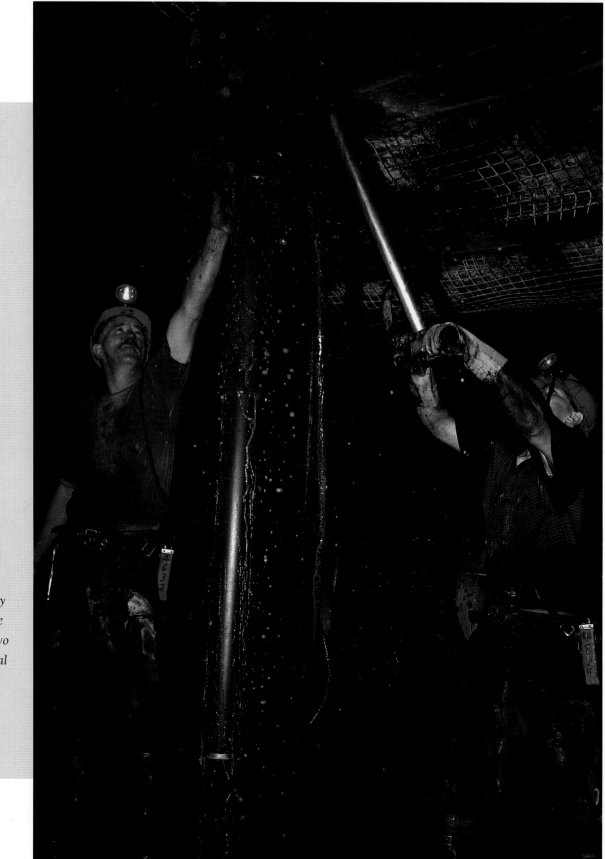

Ground support is a top priority at the Phalen Colliery in Cape Breton. For Frank Conrad and Bernard McLean it is dirty work. They must stop the continuous miner every two feet and install bolts, metal straps, and screening.

In open-pit mines, these drills were soon mounted on track-propelled rigs equipped with portable air compressors. But the hand-held pneumatic drill remained the standard in underground mining until the 1950s, with compressed air distributed by pipes from surface-installed compressors. As the mechanization of underground mines began, these drills were mounted on carrying devices with booms, allowing drill steels of adequate length for one-pass drilling, hence the development of the "drill jumbo." The next step was to add hydraulically-powered drills for greater efficiency. These machines are the standard today for the development of access drifts and in cut-and-fill mining. The development of "in-the-hole" drills, which are powered by compressed air sent down the drill hole itself, have formed the basis of modern bulk mining.

Two traditional mining methods used for steeply dipping orebodies are shrinkage and cut-and-fill mining. These methods provided the miner with access to horizontal slices of ore approximately 60 metres long and 3 or 4 metres high. The miner drills

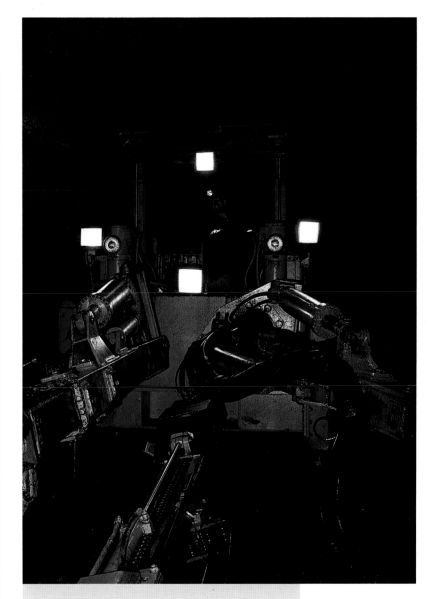

Darrell McLean operates a drill jumbo at the Ruttan Mine.

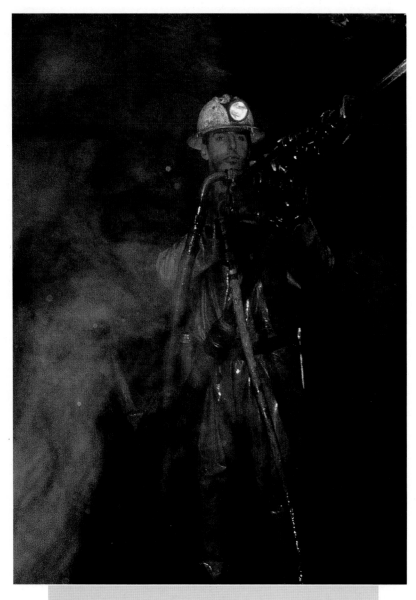

Jackleg drill operator Brent Morrison concentrating intensely on his work at the Premier Gold Mine in British Columbia.

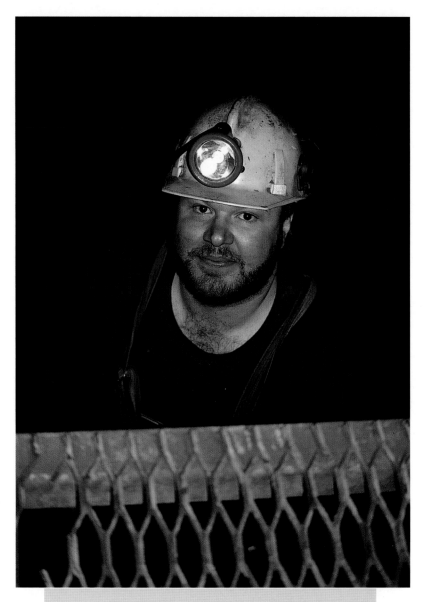

A miner heading underground at Birchtree Mine.

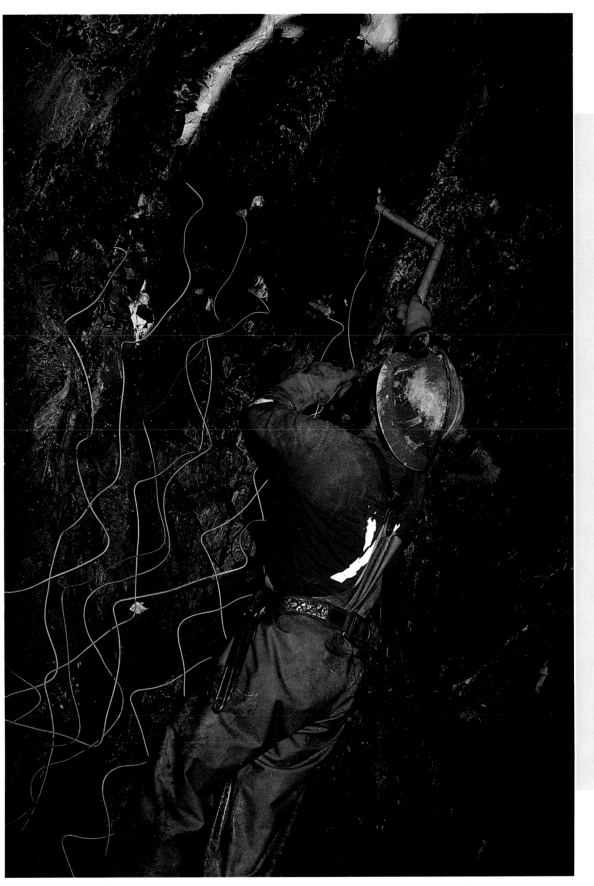

At the Golden Patricia Mine, explosives expert Lucien Girard uses stick dynamite to isolate the blast area. The coloured lines lead to a detonator in each hole. Numbered tags on each line indicate the delay time between ignition and explosion.

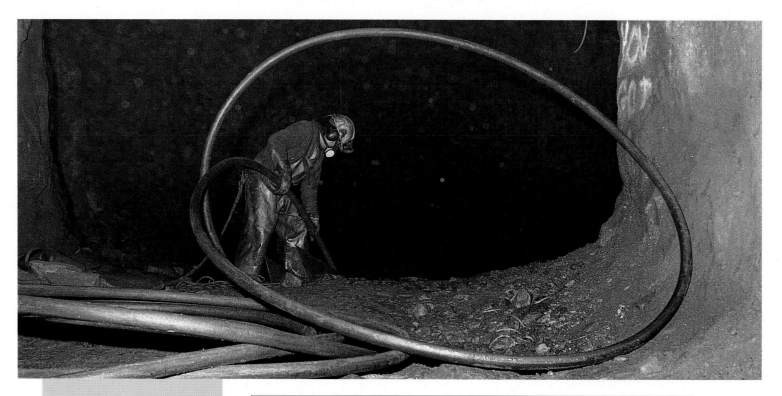

these slices using hand-held drills or drill jumbos. In shrinkage mining, broken ore is left in the stope until the stope is completely drilled. This provides a working platform from which the miner can drill the next slice. In cut-and-fill mining, backfill is placed in the stope as each slice is removed both to provide a working platform and to support the walls of the opening. These techniques are still used today in ore where the host rock is not strong enough to support the large openings created in bulk mining. Shrinkage mining is generally restricted to relatively shallow and narrow high-value gold deposits. Cut-and-fill mining has become highly mechanized and may involve large loaders and trucks entering the stope directly to remove the broken ore.

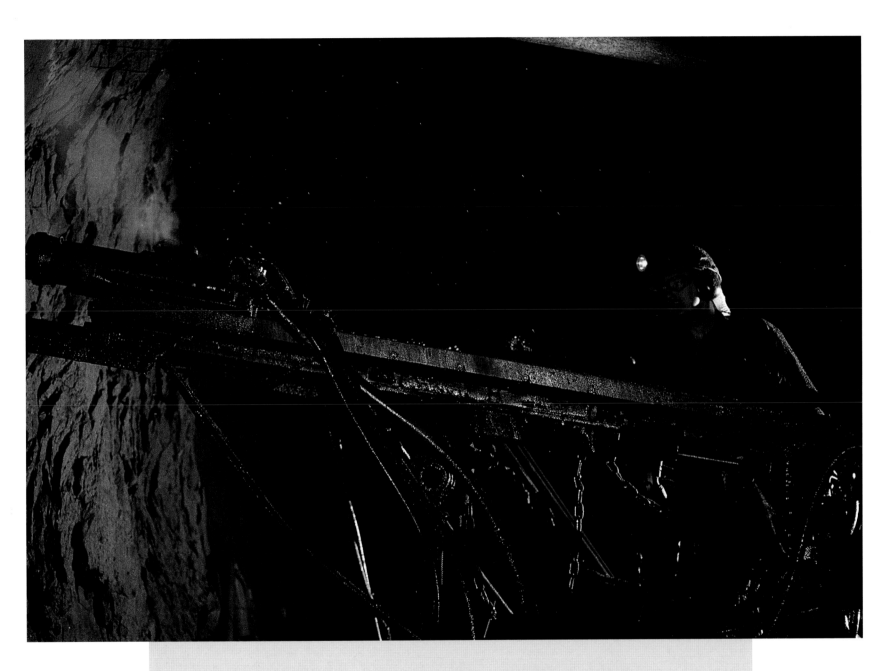

Lucien Lanteigne at work in the Brunswick Mine near Bathurst, New Brunswick.
Brunswick has converted to blasthole for a large proportion of their production.

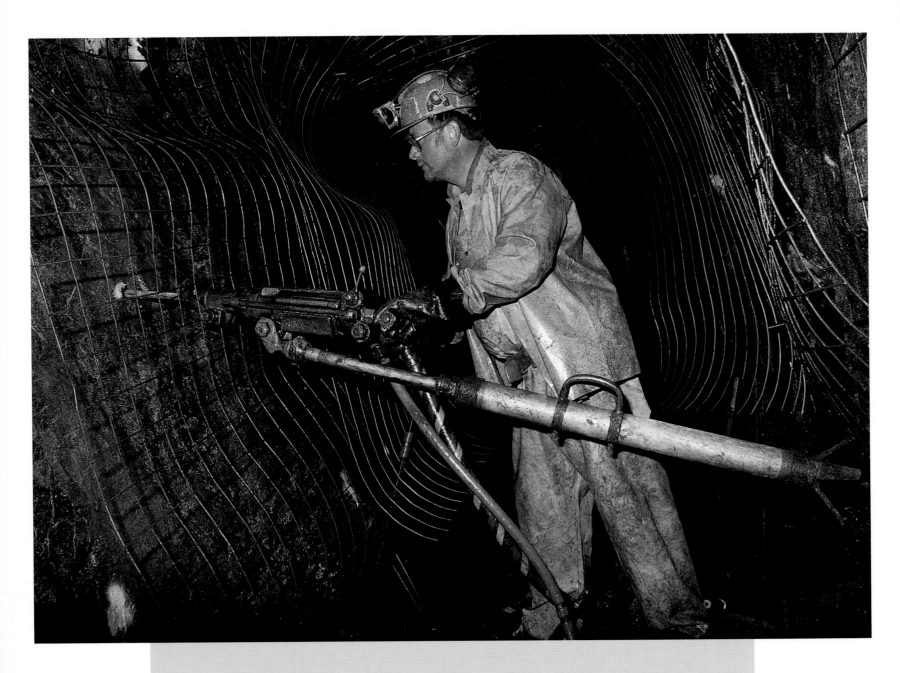

For a narrow drift, a jackleg drill is required. Pat Wagner stays in excellent physical shape by hauling this drill up and down into new drifts at the Campbell Mine in Balmertown, Ontario.

Where ground conditions and orebody geometry allow, bulk mining methods are used. In bulk mining, 40-metre-long blast holes are drilled vertically into the orebody. With older drilling technology, miners could expect significant drill-hole deviation and these long-hole methods were used only on very large orebodies. With the advent of in-the-hole drills, larger holes ranging from 10 to 20 centimetres in diameter were possible with much-reduced deviation. This allowed these long-hole methods to be used in many more mining situations. In the typical layout, the miner is exposed to in-stope rock only in access drifts above and below the ore. These drifts are typically spaced from 25 to 60 metres apart vertically. The blastholes are then drilled between these openings and the holes are loaded with bulk explosives to remove the entire ore slice. The dimensions of the typical ore slice removed in one blast would equal the vertical drift measure by approximately 25 metres along the horizontal extension of the orebody, by the width of the orebody. This piece of ore would range from 20,000 to 40,000 tonnes, depending on the thickness of the ore and its density, and would represent about ten days of production for a medium-sized mine. This material then falls through drawpoints to the drift below.

Crusher operator Andre Tremblay, at the Selbaie Mine in Quebec, keeps a watchful eye on the ore chute as ore is dumped from the levels above down to the crusher where he works.

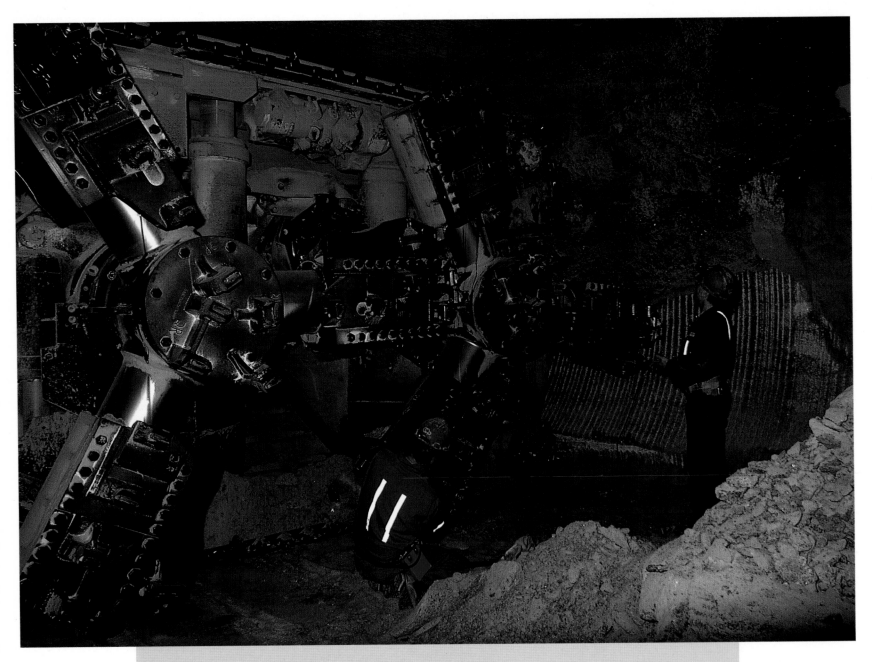

A continuous mining machine is used for soft-rock mines such as coal and potash mines. Many bits are used to cut through the rock. Over time, these wear down and must be replaced. The old bits are then taken and resharpened. Shown here is a continuous miner at the Central Canada potash mine.

The development of the remote-controlled load-haul-dump (LHD) unit has vastly improved the removal of ore from these drawpoints. The LHD unit is an articulated, low-profile, bi-directional loader developed in the Sudbury mines in the early 1970s. It loads its bucket and then travels to its dump point, an orepass system through which the ore falls to a main level to be collected before being crushed and hoisted to the surface. Because the machine is remote controlled, the operator does not have to enter the drawpoint and the opening of the stope above does not have to be supported. The ore is thus drilled from a secure drift and after it has been blasted the personnel no longer have to be exposed to the dangerous stoping area. The increased productivity of this method and the money saved by not having to secure the walls of the stope more than compensate for the rare loss of a $250,000 machine.

Ground control is important in all mining methods, but it is particularly important in bulk mining. As large pieces of ore are removed, the tendency is for the rock walls containing this ore to squeeze together. One method to control this ground movement is to leave intact pillars of ore between stopes to hold back the walls. The open stopes are cleared and then backfilled in sequence, retreating away from the area of closure. Once the open stopes are backfilled, the remaining

*Robert Robichaud gives the ore cars
an extra shove as they dump their loads
into an ore pass at the Arthur White Mine.*

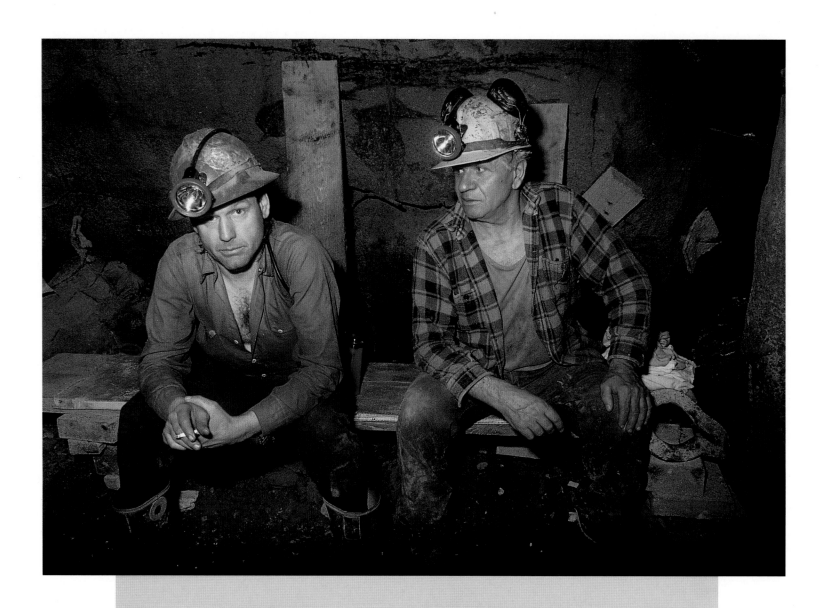

Macassa miners Randy Jack and Bob Zirovic take a break.

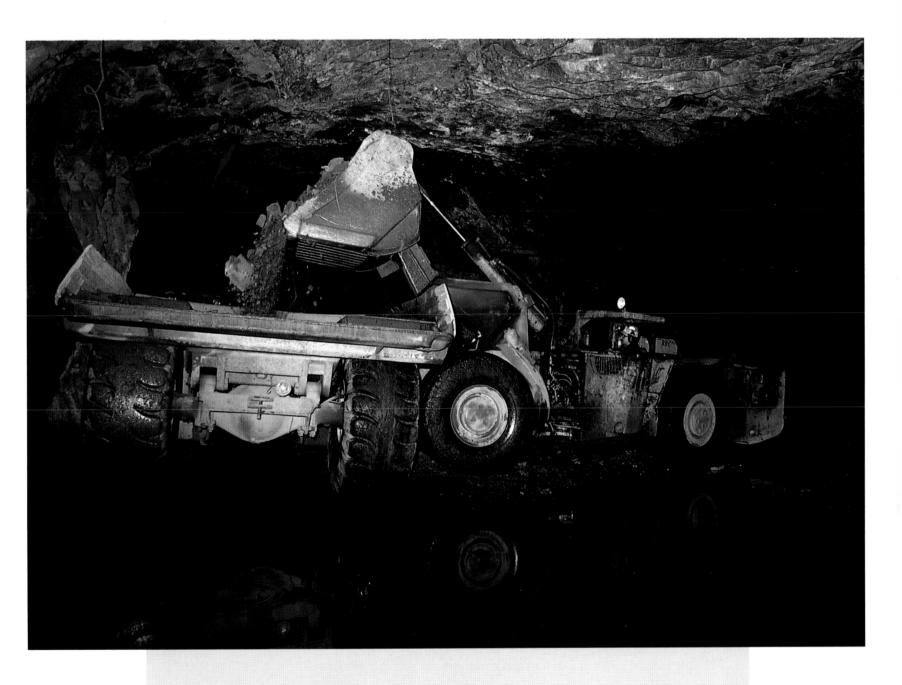

Ernest Pearle dumps his load into an electric truck at the Hope Brook Mine in Newfoundland.

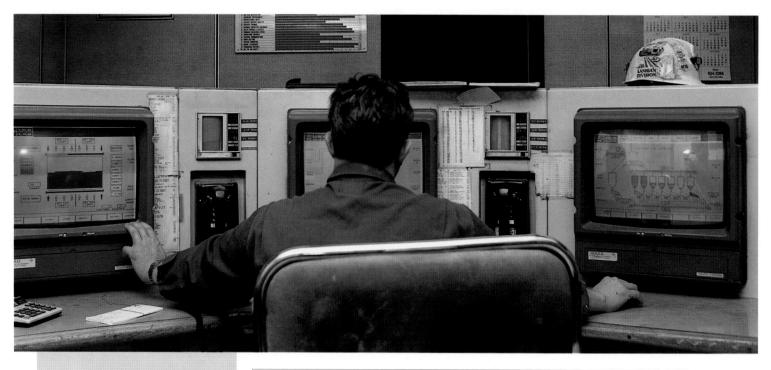

The Lanigan potash mine in Saskatchewan has been so completely computerized that Lloyd Howden can watch the computer panels in the underground control room and know exactly how much ore is being mined, what equipment has broken down, and what parts are needed.

pillars can be blasted and extracted. The miner is not exposed to any of the potential movement or falls of ground that may occur in these openings.

There are two types of material used for backfill. The most commonly used is tailings, the waste matter left over after the milling of the ore. Tailings are mixed with water and the slurry is then poured into the open stopes. The added benefit of this is the reduction in the amount of tailings requiring surface disposal. Sometimes tailings cannot be used for backfill, either because it is made too fine in the milling process and is difficult to dewater or because it is too high in sulphide minerals and would produce dangerous gases if it were to oxidize underground. When this is true, crushed rock or alluvial sand is used instead. Either way, the

backfill material is cemented so that it remains stable as the remaining pillars are removed.

Another important mining method is used in flat-lying deposits. The room-and-pillar method consists of excavating large expanses of the orebody leaving rock pillars to support the roof. The exact size of the rooms and the pillars depends on the nature of the rock and the depth of the orebody. This method is used in the uranium deposits of Elliot Lake, where production will cease by 1996. The larger mines using this method include the potash deposits in Saskatchewan and New Brunswick, salt mines in Ontario and Nova Scotia, and underground gypsum mines in Ontario. In these softer evaporite orebodies, the ore is not blasted but is instead cut away using large machines with rotating cutters containing hardened picks or discs. These mines may extend for considerable distances along the flat orebodies. Conveyor systems are used to bring the material to a central area for hoisting to surface.

A final underground mining system is the longwall method. This method is used in the coal mines of Nova Scotia. Giant cutting machines move along a wall of coal that may be several hundred metres in length. With each pass the machine cuts between 10 and 20 centimetres of coal, which is removed by chain conveyors to the end of the longwall. It is then whisked away by conveyor systems. Access along the entire wall is maintained by hydraulic supports, which are advanced as the long wall advances, allowing the layers behind the opening to collapse. Thus access is maintained only long enough to extract the material.

As these brief descriptions demonstrate, underground mining has become very heavily mechanized. The machines used demand skilled operators and mechanics, and mines must be well designed and sequenced in order to remain productive. Research into increased levels of mechanization and automation is ongoing to ensure the competitiveness of underground mining in Canada.

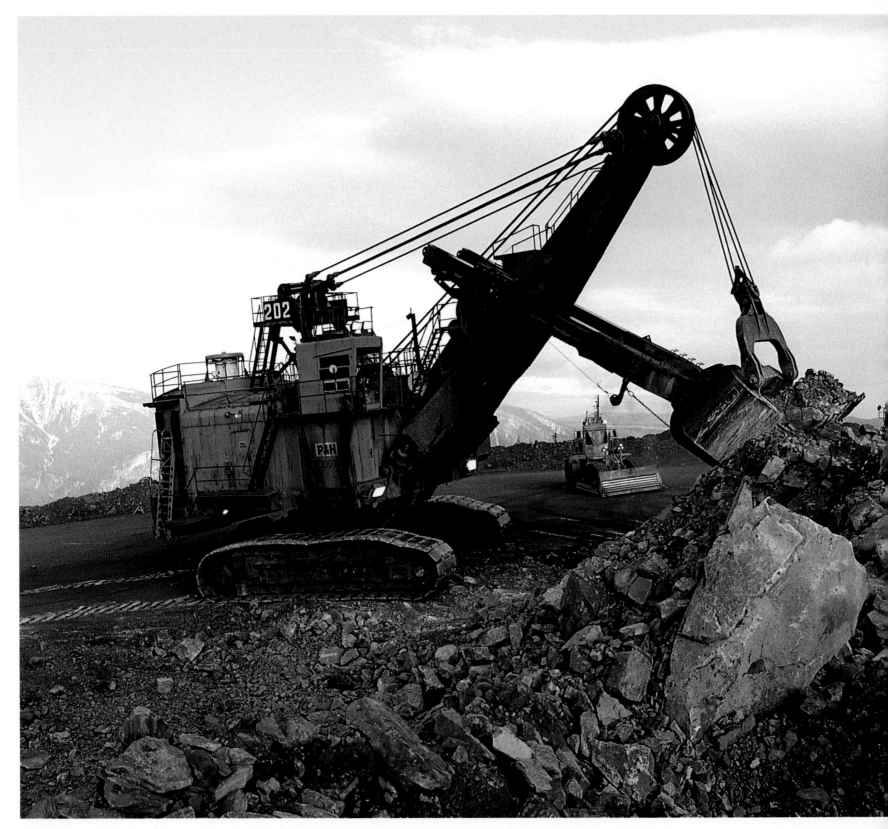

The Quintette Mine is the largest open-pit mine in Canada.
The shovels work continuously to produce in excess of 130,000 tonnes of coal per day.

CHAPTER SIX

OPEN-PIT
MINING OPERATIONS

Flat-lying bedded deposits that are close to surface are usually mined by open-pit methods. In the beginning, the cost of moving a tonne of material by open-pit methods is significantly less than by underground methods. Since the mine operates from the top down, waste material at the orebody margins or contained within it has to be moved in order to access the ore. As the pit depth increases, however, the cost of moving the waste increases. Either the operating cost of moving this waste makes the remaining ore uneconomical or it becomes more economical to mine the ore by underground methods. At the Kidd Creek operation, for example, an open pit was used for the first 200 metres but the mine has been continued to a depth of over 2,000 metres by underground methods. The environmental disruption that occurs in open-pit mining is generally greater than with underground mines, although current legislation requires that a rehabilitation plan be developed before any new mine is allowed to proceed.

While open-pit operations exist at many Canadian locations, the following are the present important centres of open-pit mining. In the Labrador Trough three large iron-ore mines operate: two in Newfoundland and one in Quebec. In the Eastern Townships of Quebec, even with the asbestos market in decline, there are still three significant operations. Uranium is produced from open pits in northern Saskatchewan, though increasing underground production is foreseen in the future. The two tar-sands operations in Fort McMurray are very large, as are both the thermal and metallurgical coal producers of western Alberta and eastern British

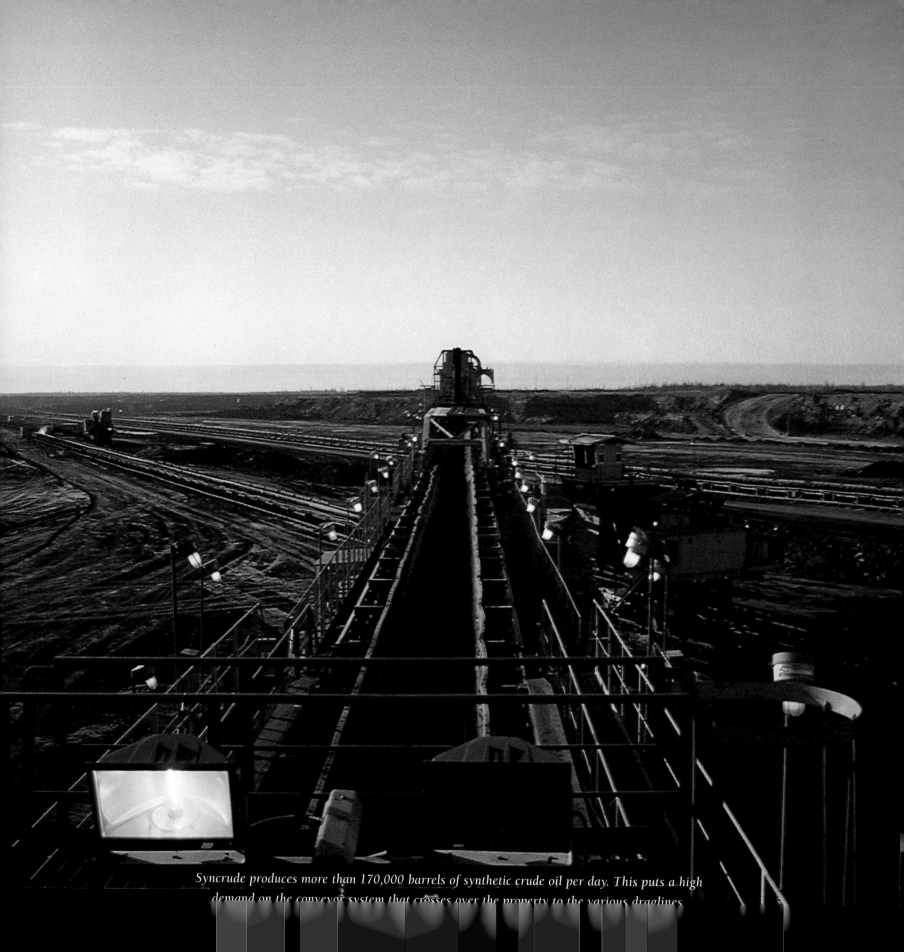

Syncrude produces more than 170,000 barrels of synthetic crude oil per day. This puts a high demand on the conveyor system that crosses over the property to the various draglines.

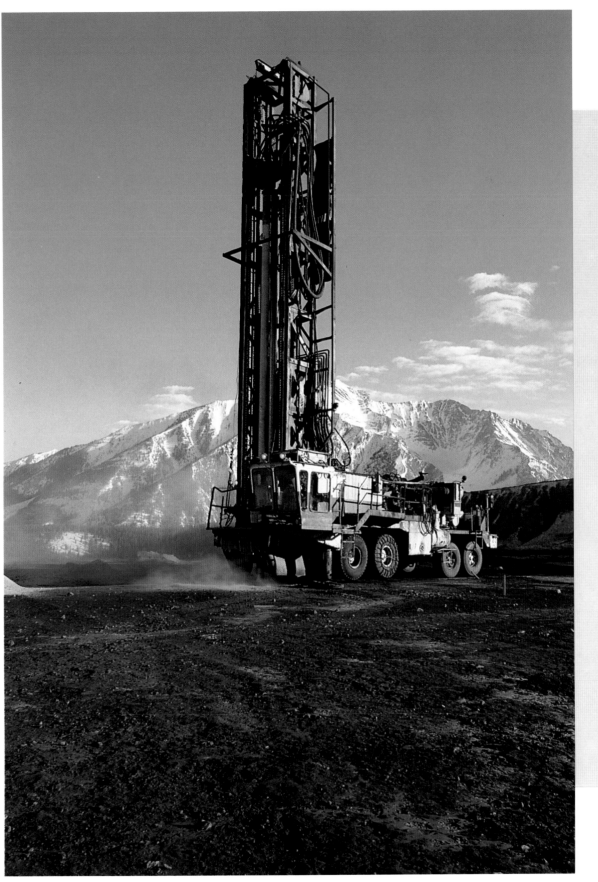

Large mobile drills such as this at Byron Creek Colliers are used to drill the blast holes at an open-pit mine.

Columbia. Although the industry has been declining in recent years, there are still several major copper producers in British Columbia (including the large Highland Valley operation) and new operations have received environmental approval. The production of industrial aggregates takes place country-wide; these mines are usually located relatively close to population centres, which use the products in the construction industry.

Open-pit mining requires the efficient operation of a massive materials-handling system. Mining is carried out in flat benches ranging from a few metres high, in selective operations such as the uranium mines, up to tens of metres high in the stripping operations of coal mines. In harder rocks the benches are generally around 15 metres high. With the exception of some of the softer material in the coal and tarsands operations, material must be blasted before removal. For this, vertical holes about 1.5 metres deeper than the bench height are drilled with diameters ranging from 10 to 45 centimetres. For the larger holes, the personnel loading them with explosives have to wear bars strapped across their bodies to prevent them from accidentally falling in. Drilling is carried out using large electric rotary drills with masts high enough to provide storage of adequate drill rods. This allows single-pass drilling, thus increasing efficiency. Special tricone drill bits contain either steel teeth or tungsten carbide inserts to break the rock as the bit rotates.

Drill holes are spaced 5 to 10 metres apart and are loaded with bulk explosive slurries or emulsions. An unloaded portion is left at the top, which is filled with fine gravel. This gravel contains the explosive gases in the hole and reduces the amount of flying rock. Rather than blasting all of the holes at once, which would result in dangerous vibrations, holes are blasted in rows with a short delay from one row to the next. This allows the rock in the previous rows to begin moving away, creating space for the following rows. Blasts of up to several million tonnes have been carried out at the larger operations.

After blasting, the next step is to move the material. In the tar sands and some coal operations, massive draglines are used to cast the overburden the required distance to uncover the

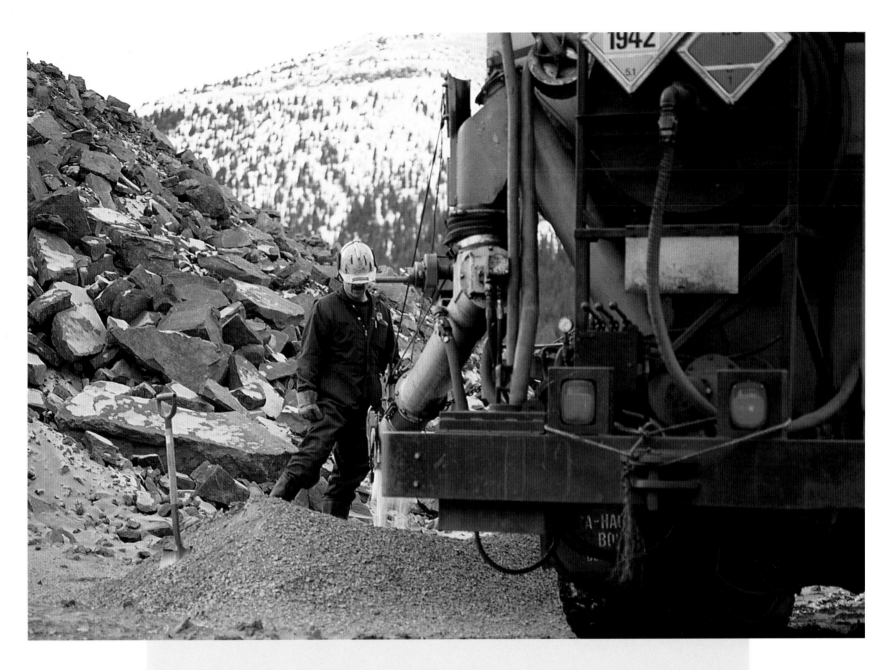

An explosive mix (a combination of ammonium nitrate and fuel oil) is brought in by the truck load
to fill the large drill holes. At the Smokey River coal mine, Derek Flanagan measures
the exact amount of explosive for each hole.

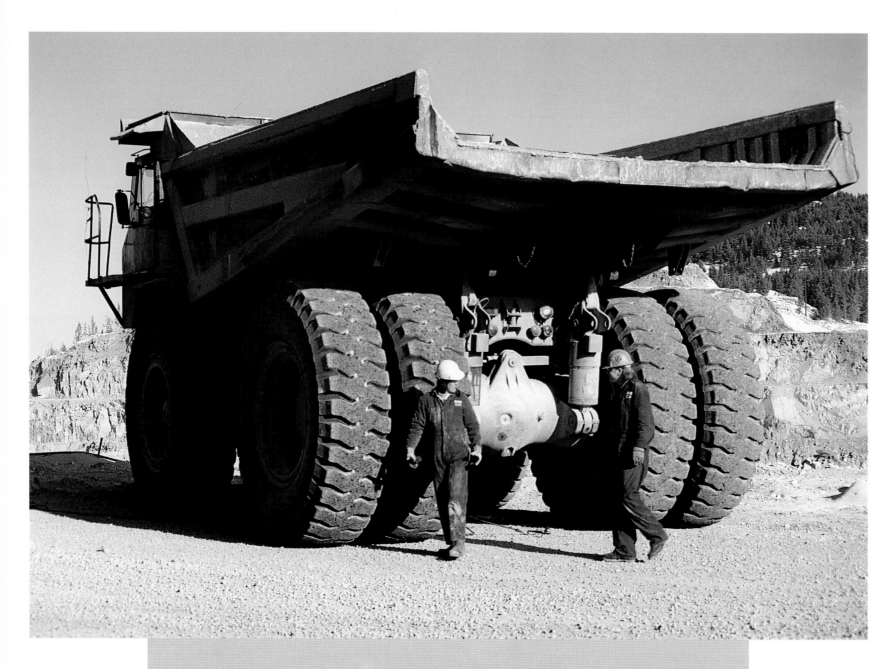

Closed and reopened many times, Nickle Plate Mine has been dubbed the mine that refused to die.

Open-pit mines commonly use trucks that haul up to 150 tonnes of ore at a time.

High maintenance demands keep Don Haggerty and Andy Holzapfel on their toes.

Truck driver Binart Turgeon checks over his 105-tonne ore truck before beginning a day's work at Black Lake Mine.

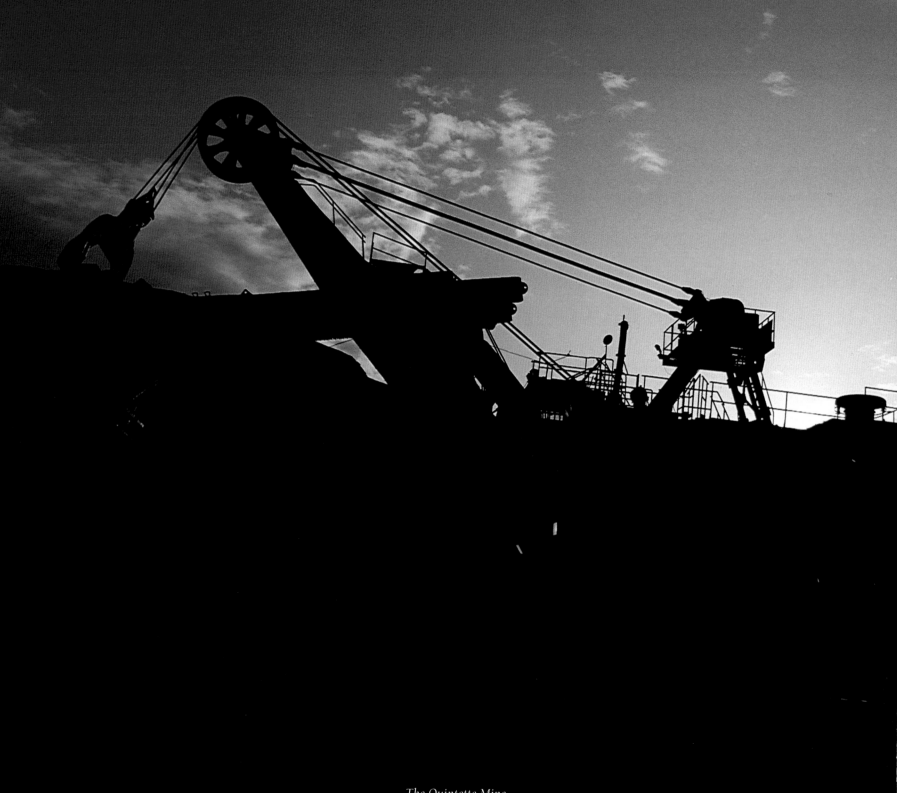

The Quintette Mine.

valuable material beneath. Big Muskie, the world's largest dragline, which operates in Ohio, has a boom length of 95 metres, a bucket capacity of 170 cubic metres and a weight of over 12,000 tonnes. It can move over 17,000 tonnes of material per hour. The draglines at the larger Canadian operations are only slightly smaller than this machine.

Electric shovels or rubber-tired loaders are used to load trucks. The buckets on the larger electric shovels can carry more than 20 cubic metres of broken rock. The loader buckets can carry more than 10 cubic metres. The efficiency of the dragline or loading operation is critical to the pit operation. For the dragline, operators must design worksites that minimize the amount of time that the machine swings from the loading site to the dumping site. For shovels, the worksite must be arranged so that one truck can position itself near the loader while another truck is being loaded. A few seconds saved at each load can mean much higher productivity over the duration of the operating shift.

The haulage trucks used in large open-pit operations can carry loads ranging up to 270 tonnes, with the 150-tonne capacity unit being the most common. These massive trucks weigh over 100 tonnes, have a length of 12.75 metres, a width of 6.25 metres and a height of 6.7 metres. The operator must climb a ten-step ladder to reach the air-conditioned cab and only begins to see the ground 12 metres in front of the right side of the truck. The larger trucks are propelled by electric motors that drive the rear wheels. These motors are powered by an on-board 1,000-kilowatt generator driven by a 1,600-horsepower diesel engine. The tires on these vehicles are more than twice the height of operator. The cost of the six tires is over a million dollars. Heat build-up in the tires has been the limiting factor in increasing the size of the haulage units.

In some operations (such as the Highland Valley Mine in British Columbia) long distance haulage is carried out using conveyors. This is a much more efficient way to transport material and it eliminates the need for these expensive haulage units. The conveyor system necessitates the use of in-pit crushers to reduce the blasted material to a conveyable size. These

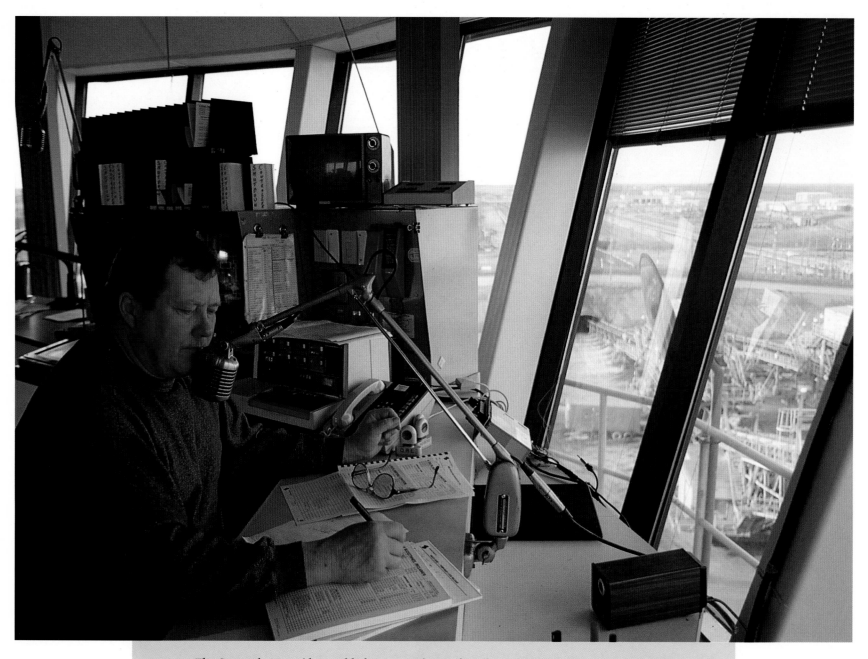

The Syncrude Mine (the world's largest producer of synthetic crude) employs approximately 4,300 workers and up to 1,000 contract employees. High above the mine is the control tower, where supervisor R. Doherty keeps a watchful eye on the operation.

crushers are built on movable platforms to allow relocation as the pit deepens. The disadvantage of these systems is in the time required to relocate them, which reduces planning flexibility.

Computerized dispatching systems are commonly used in modern pit operations to control the movements of the haulage trucks and support equipment. Radios aboard the trucks relay signals from transmitters along pit roads, allowing computers to know their exact location. These computers then direct the trucks to the first available loading unit or dump location, thus preventing inefficient line-ups at these points. They also control the grade of the material being moved, schedule the trucks for refuelling and maintenance, and collect production statistics. Such systems have further increased production efficiency.

At first, truck drivers were concerned that these systems might encroach on their privacy. However, managed wisely, the systems provide constant direction and increase the safety of lone operators. Because of these advantages, these systems were soon readily accepted by the operators. While the next logical step might seem to be the complete automation of the haulage unit, there has been very little effort directed at achieving this. The wages paid to the operator are a minor part of the cost of operating such a large piece of equipment, and the cost of developing and maintaining such automated systems would likely exceed the existing labor cost. In addition, sensors and computers have still not been made that can match the skill of a human operator.

The provision of services is the final requirement of an efficient open-pit operation. Electric power must be distributed to the drilling and loading equipment. Pumps and pump lines must be maintained to dewater the large catchment area of the pit. Roads must be maintained for the massive haulage equipment and for the delivery of explosives and other supplies. In Canada, these functions have to be carried out under severe climatic conditions on a year-long basis. In the winter, driving snowstorms have to be endured. The snow must be removed rapidly and the roads sanded. In the spring and fall, dense fog can severely limit visibility for

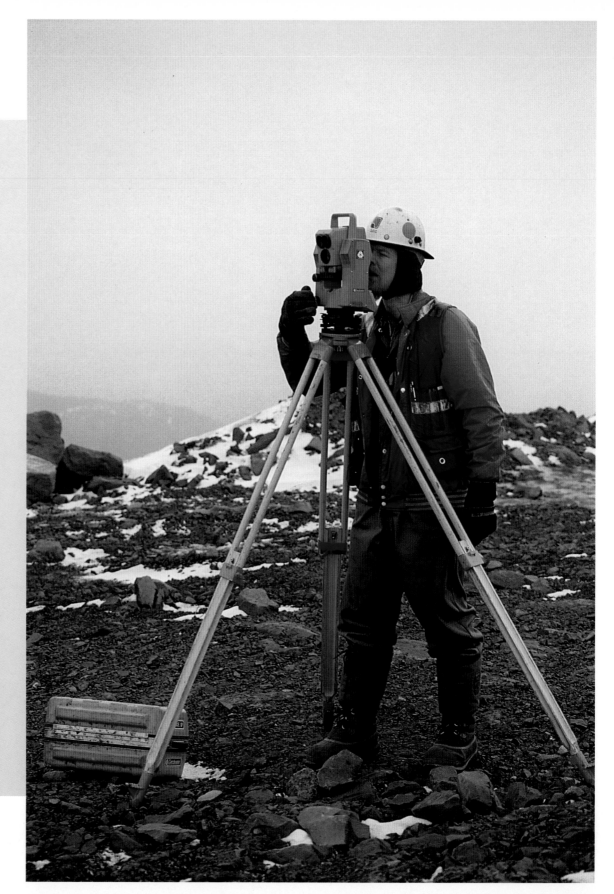

The coal seams at the Quintette coal mine are highly faulted and convoluted, so every aspect of the mining has to be taken into account before proceeding. Surveyor John Stokman monitors the work carefully.

the truck operators. In spring, with heavy trucks passing over them constantly, the thawing roads rapidly deteriorate and the melting snow puts the dewatering crews on constant alert. In the summer, the fine dust created by the grinding action of the massive tires requires constant wetting to prevent health risks to personnel and damage to equipment.

All of these activities must be carefully engineered and planned. Temporary and permanent road systems must be designed for access. Blasts must be designed and planned to provide an adequate supply of properly graded ore to the milling operation. The pit must be adequately surveyed using modern survey instruments and pit walls must be monitored (often by laser systems) to ensure their stability. The most recent technology in use includes computer algorithms to design optimum pits and satellite-based global-positioning systems to control the mobile equipment, even allowing drills to be positioned over the next blasthole.

The large open-pit operation is efficient, cost effective, and very impressive. Some Canadian operations move over 500,000 tonnes of ore and waste per day.

*The ore screen is washed off at the Lanigan potash mine to remove clay from the ore,
leaving clean potash and salt, which are then pumped into holding tanks.*

CHAPTER SEVEN

THE MILLING OPERATION

After ore has been extracted, the essential next step is to concentrate the valuable minerals to a level where they provide a salable product. This may involve separating several minerals into individual products for shipment to different customers. Where the nature of the mining operation is influenced most by the size, shape and location of the deposit and on the physical characteristics of its host rock, the separation process depends almost entirely on the physical and chemical characteristics of the desired minerals themselves. The process can be a purely physical one if the minerals can be differentiated by such qualities as differences in density or magnetic attraction. However, chemical processes such as precipitation, involving the total dissolution of all the minerals present and then the separation of the economic minerals, can also be used.

The material remaining after the economic minerals have been removed is called tailings and must be disposed of. As previously described, a portion of this material may be disposed of underground as backfill. The disposability of this product is determined by both its fineness and content. It the tailings are too fine, they cannot be properly dewatered after they are backfilled and are environmentally unacceptable. Likewise, if the chemical composition of the tailings is toxic, they are unacceptable as backfill.

In certain mining operations the product does not need to be upgraded before sale. This is common for industrial aggregates and coal production, but has also been true for some metallic mines. The direct-shipping iron ores of Schefferville, which were supplied directly to the Bessemer blast furnace, and the rich sulphide ore first mined at the Pine Point operation are two examples of this. In aggregate production, the product generally has to be crushed, sized,

Assayer Dave Fetterly removes ore samples from the furnace at the Arthur White Mine.

and sometimes recombined according to close specifications supplied by the consumer. There may be some excess of fine material, essentially sand, that requires disposal. In the case of coal operations, the product has to be crushed, washed and sized to remove and dispose of impurities such as ash and clay before shipment.

When ore requires upgrading, it is first reduced in size until the various components exist as separate minerals or until the fraction containing the economic minerals can be adequately concentrated to justify a more expensive concentrating process. The first step in size reduction is blasting, which produces boulder-size material. The next

At the Kalium potash mine, potash is stored in huge storage sheds until shipment can be arranged.

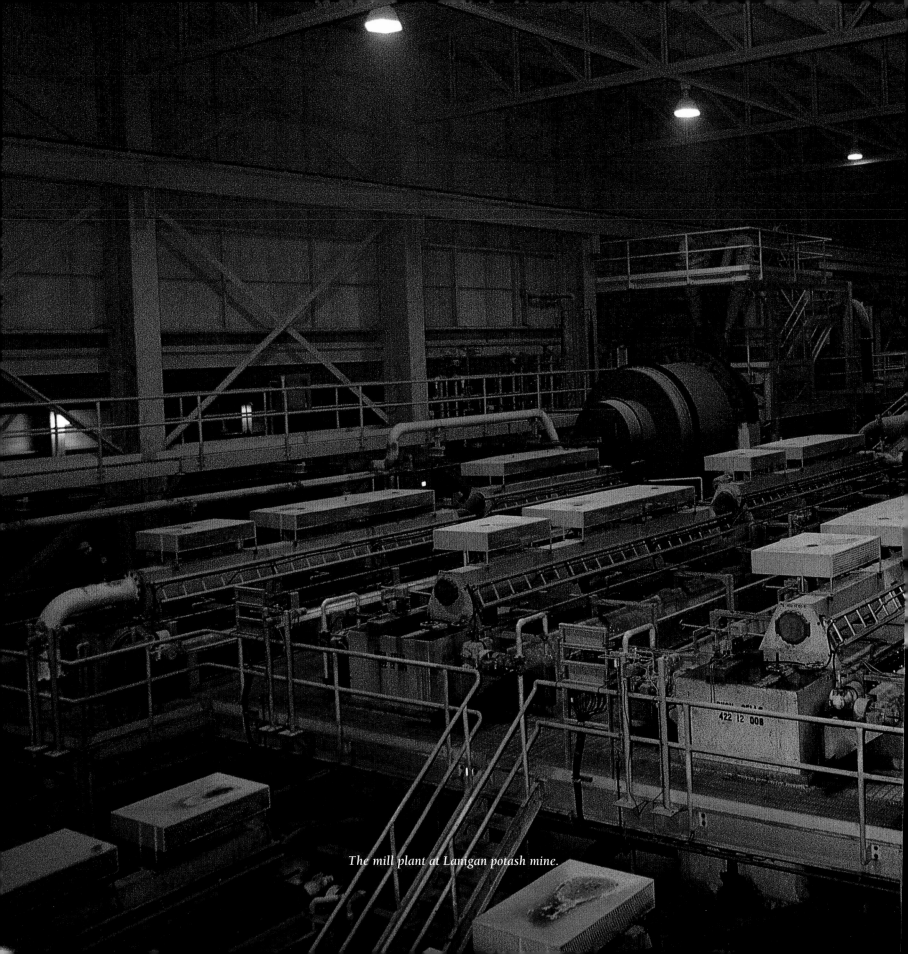

The mill plant at Lanigan potash mine.

step is primary crushing, which, for the harder ores produced in metal mining, is done with a pressure crusher. There are two types of pressure crusher: a jaw crusher, which uses one fixed and one moving plate to squeeze the material, and a gyratory crusher, which breaks the ore between circular outer wear plates and a centrally rotating steel cone. These crushers will typically break the ore into rocks around 15 to 20 centimetres in diameter. Secondary crushing, using cone crushers similar to the gyratory crushers, further reduces the material into gravel-sized stones. The final stage of size reduction occurs in grinding mills. These are essentially rotating drums that contain either steel balls or rods to grind the material as they cascade together inside the rotating drum. If the properties of the material permit, these last two stages may be combined in an autogenous grinding mill in which the larger pieces are used to grind up the smaller pieces.

The removal of the very dense free-gold grains from the gravels in placer-gold operations can be accomplished by gravity. Iron is also much higher in density than its host rock and can be separated in this way. After being crushed and grinded, the liquified material is run through a series of metal spirals. Through centrifugal force, the heavier material moves toward the outside of the spirals and is removed through a series of adjustable openings.

Certain products can be upgraded much more easily. Asbestos ore, for example, breaks preferentially along fibre veins when it is broken by impact. The upgrading process therefore consists of a series of impact crushers after which the lighter fibres are removed by air suction as the material flows over vibrating screens. Magnetite, a type of iron ore, can be removed on magnetic drums. Minerals found in a host rock with a significantly different specific gravity can be separated by placing the material in a solution that has a specific gravity somewhere between the two. This causes either the desired mineral or the host rock to float. Certain types of ore can even be differentiated by color. A computerized system activates air jets that split the material into two products as it falls off the end of a slow conveyor belt.

More typical, however, are the complex base-metal sulphide deposits, which form the core

Assayer Matt Makela determines the level of gold content in samples taken at the Arthur White Mine.

of Canadian metal mining. In these ores the individual minerals exist as very small grains intergrown in very complex relationships. They must first be ground to a size so that the individual minerals exist as separate grains. Not only must these economic mineral grains be separated from the waste minerals, but many of these ores contain multiple economic minerals that must also be separated from each other before smelting. The usual process for separating these sulphide minerals is called flotation. The crushed ore is treated with certain chemicals that allow air bubbles to adhere to the surface of the desired minerals. Frothing agents similar to soap are added to the solution. The

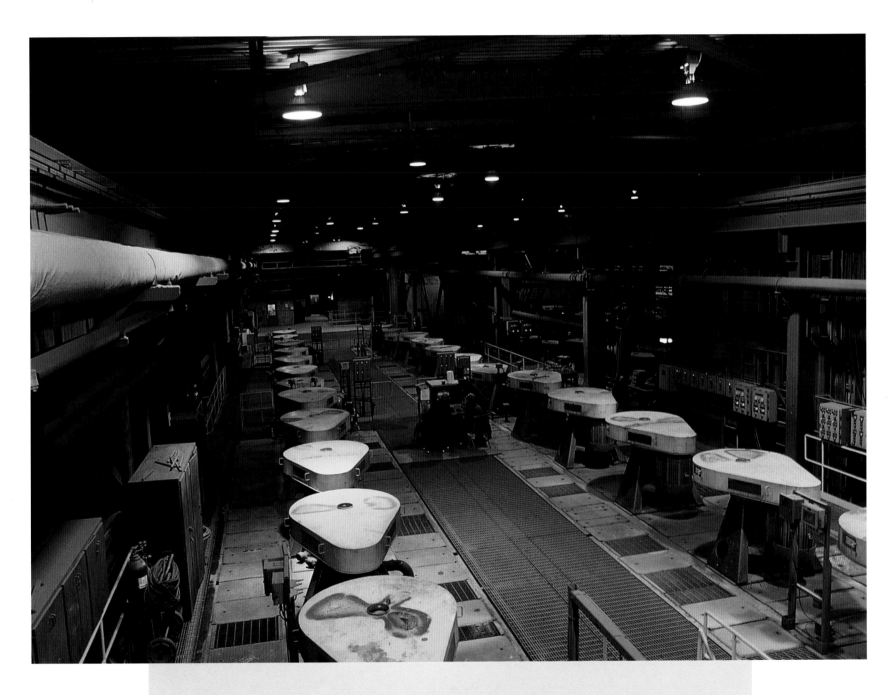

Michael Croteau and Albert Gouliquer watch the controls for the flotation system at the Selbaie Mine.

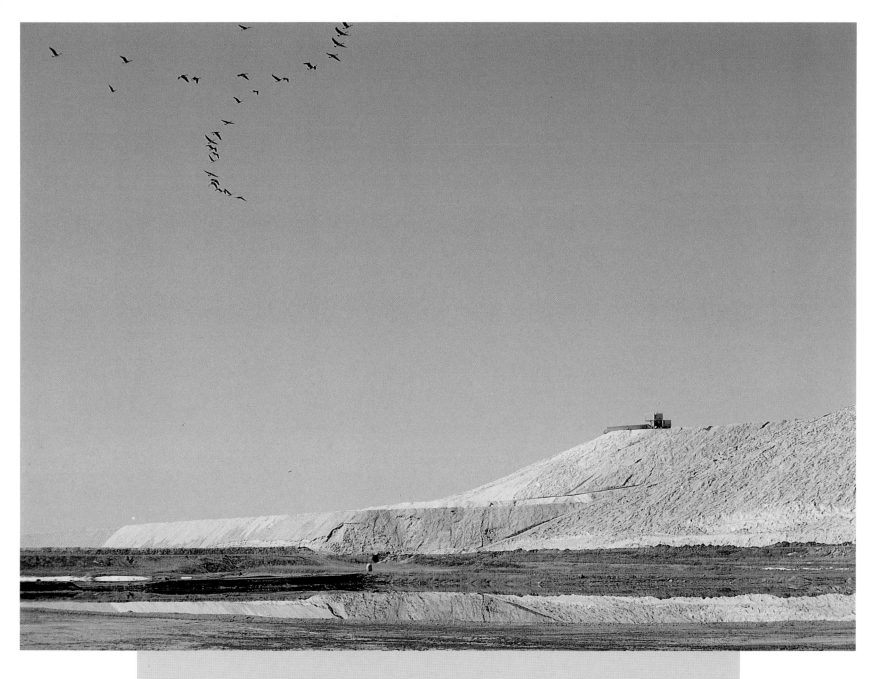

At the Rocanville potash mine, the salt by-product is piled up at surface.
Future uses for this are being investigated.

material is then passed through metal cells through which air bubbles rise. The material is kept in suspension by agitators. The treated minerals are caused to float and are skimmed off with the froth that forms at the top of the cells.

There are four common types of these base-metal deposits in Canada. The deposits of Sudbury and Thompson contain nickel, copper, and precious metals such as gold, platinum and palladium. These would be separated into both nickel and copper concentrates. The rejected material would contain the iron sulphides pyrrhotite and pyrite as well as the host non-metallic minerals. The ore at Brunswick Mining in Bathurst, New Brunswick, contains massive sulphides with economic minerals such as zinc and lead, along with high levels of silver. These must be separated, thus leaving high concentrations of pyrite in the remaining tailings. The grinding required to liberate these individual ores results in a product with the consistency of flour. There are also the copper-zinc ores of the Kidd Creek operation in Timmins and the mines around Flin Flon, Manitoba. Finally, there are the porphyry-copper deposits mined in large open pits in British Columbia. These contain predominantly copper minerals, with the value enhanced by minor amounts of gold. Precious metals are often found in the concentrates of other economic minerals and are separated at the smelting stage.

A chemical dissolution process is used for certain important Canadian ore minerals. When gold occurs in sulphide minerals, the ore is dissolved in a cyanide solution. Gold ions adhere to carbon particles in the solution. These carbon particles are then chemically stripped to produce a solution rich in gold. The gold in this new solution is precipitated through an electrochemical process before being melted and poured into gold bars. Uranium is concentrated through chemical dissolution in acid and is subsequent precipitated as yellowcake, a uranium oxide. A third major mineral concentrated in this manner is copper that occurs as an oxide mineral. While these chemical processes require what might be considered dangerous chemicals, the chemicals are confined to the milling circuit and any solutions released to the environment are treated to meet emission standards.

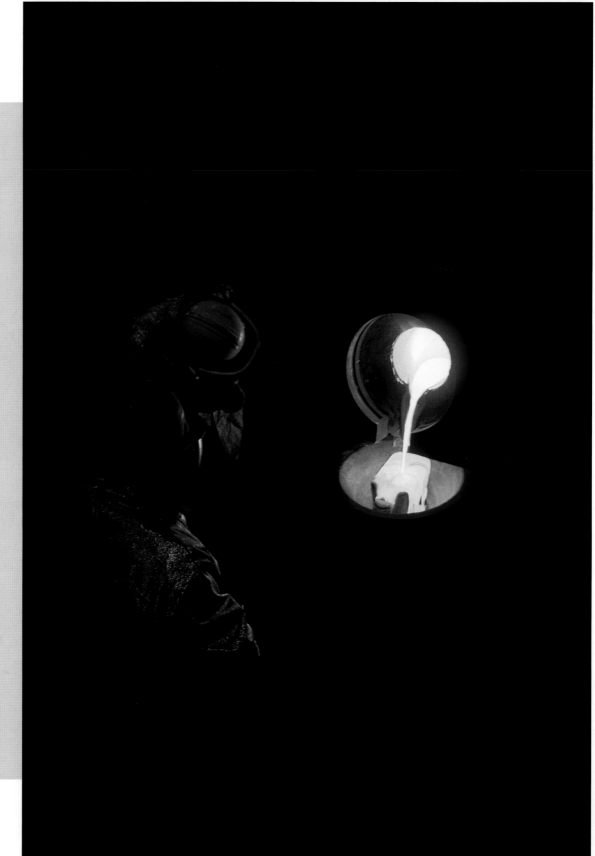

Cyrill Billard and Bruce Pittman wear heat-resistant suits to protect themselves while melting down gold ore at the Hope Brook mine. Once cooled, each bar is carefully weighed, marked and recorded.

All modern mills are highly automated and do not require many human operators. The various conveyors and pumping circuits, grinding mills, flotation cells, and chemical leaching tanks are monitored by remote sensors. Data about the condition of these systems is forwarded to a central panel from which all functions are controlled. Remote cameras may even provide visual surveillance where necessary. This entire control system is computer assisted using "fuzzy logic," a form of artificial intelligence that simulates the decisions of a human operator. All systems are equipped with alarms should they operate outside of normal limits, and particularly where environmental concerns exist, records are maintained for later review. The total personnel requirement for a medium-sized concentrating plant, including shift operators and maintenance personnel, is usually less than thirty.

The mills of today are more efficient and environmentally friendly than those of the past. But the building of these technologically advanced milling systems requires massive capital expenditure and the milling process generally consumes much greater energy than does mining. Many mining operations have failed economically due to inefficient milling processes. This demonstrates that a detailed design by qualified engineers is critical to success of the milling operation.

Dave Greenberg examines the cut patterns left by the continuous mining machine at the Lanigan potash mine. From these, he can determine if the bits are starting to wear down.

MINE SYSTEMS MAINTENANCE

P revious chapters have described the high level of mechanization that has developed in Canadian mining. In many operations the cost of maintaining this equipment accounts for one-third of the total production costs. However, these costs are much lower than the losses that would be incurred if production targets were not met due to equipment breakdown. Well-trained maintenance managers and tradespeople have supplied the Canadian mining industry with top-level maintenance support in remote locations and under the harshest of climatic conditions.

In remote locations, it is beneficial to design redundancy into the system — in other words, to have spare on-line equipment. The Carol Operation of the Iron Ore Company of Canada, for example, uses paired crushers. Both of these are required for full production, but if one breaks down or requires maintenance, production does not cease entirely. The liners for these crushers require changing on a regular basis. The process for this was designed to take in excess of twenty-four hours but maintenance crews have developed procedures to accomplish it in ten. Personnel from as far away as Australia have travelled to Labrador City to see the process in action. Skilled maintenance crews are constantly on call to service such critical systems.

That kind of redundancy is not always possible due to increased capital costs. Critical capital-intensive systems such as the hoisting facility in an underground mine or the primary crusher and conveyor in an open-pit mine are usually not duplicated and thus become critical life-line systems.

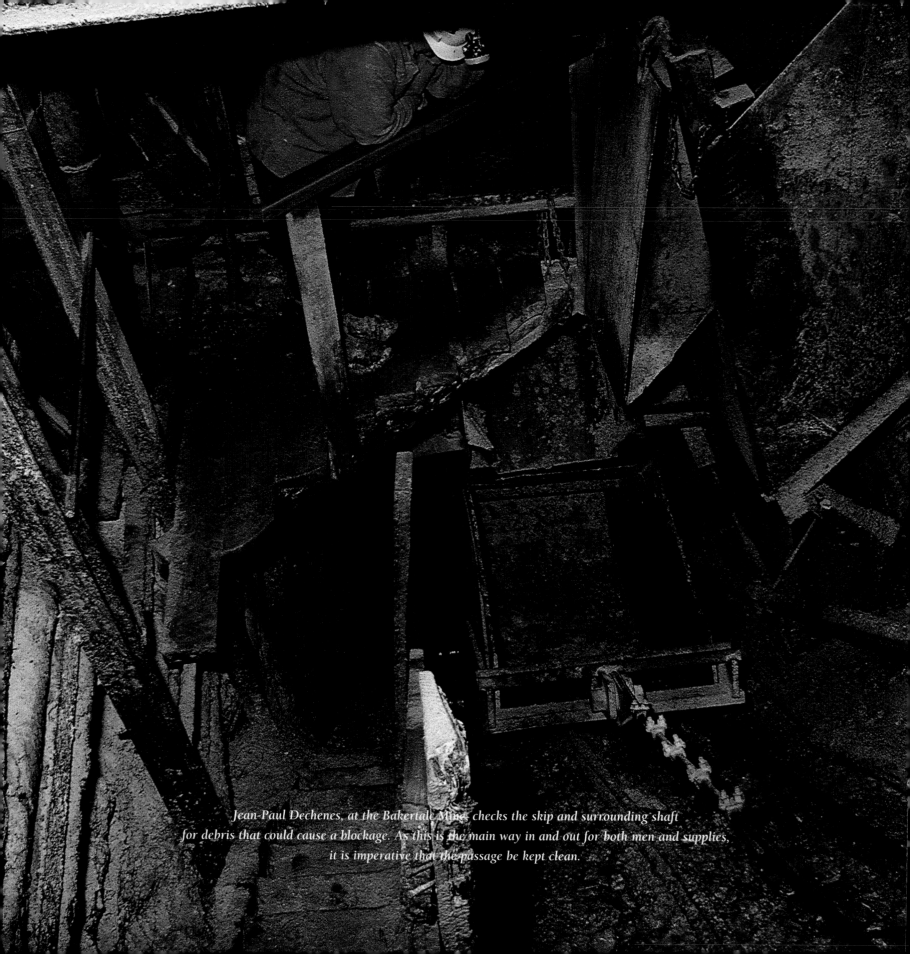

*Jean-Paul Dechenes, at the Bakertalc Mine, checks the skip and surrounding shaft
for debris that could cause a blockage. As this is the main way in and out for both men and supplies,
it is imperative that the passage be kept clean.*

Another key in remote locations is to design or purchase systems that minimize the required spare-parts inventory. For a large mine, this inventory can cost tens of millions of dollars to stock. It also has to be housed and managed, adding to that cost. The spare-parts inventory is minimized through the standardization of carrier components, such as transmissions, pumps and motors.

Maintaining equipment in severe climates presents several unique challenges. Special oils and lubricants are required in very cold climates. I recall one incident in Labrador City when the temperature rose some thirty degrees Celsius in a very short time, from a low of about minus thirty to the freezing point. Within a few hours, failures occurred in the main steel frames of two large electric shovels. Special alloys have since been developed to prevent such premature failures under thermal stress.

Maintenance crews must often work on equipment under less than ideal conditions. In an open pit, large equipment such as shovels and drills are relocated to a repair facility only for major overhauls. This means that even major repairs must be effected in the field. This

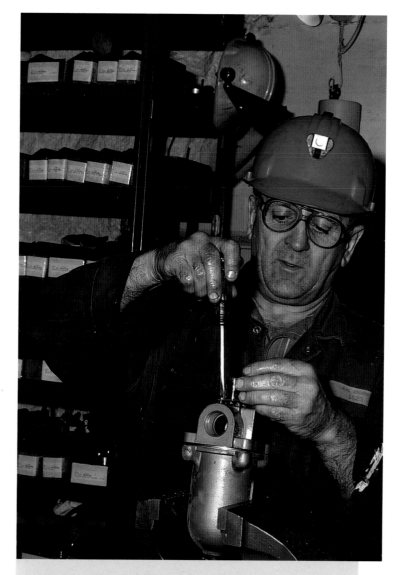

Sometimes mine maintenance equipment requires repair. Here Lavel Gagnon repairs a drill lubricator at the Niobec Mine in Quebec.

*Steve Kolesar at the
Golden Bear Mine climbs up
the crib wall support as
he builds it higher.*

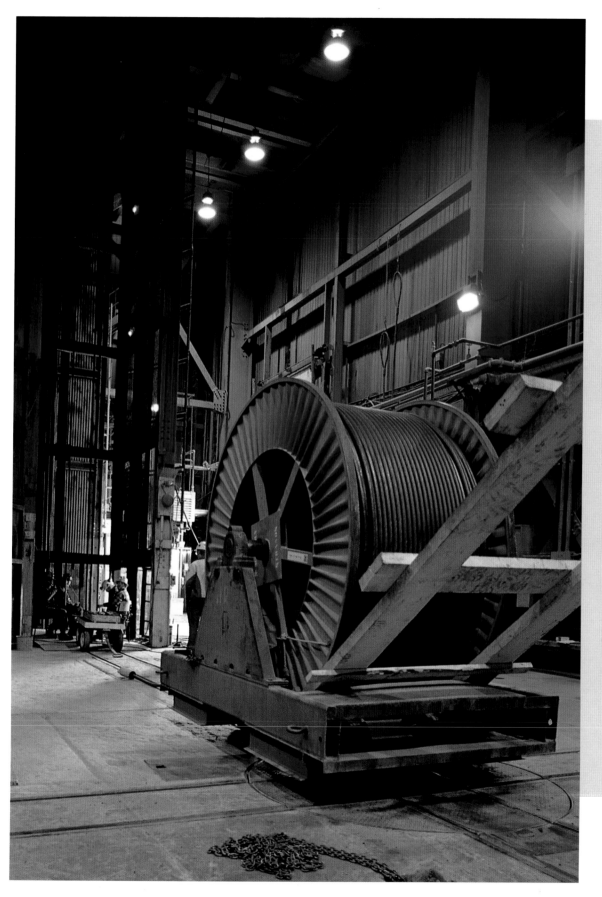

Changing hoist cables is a job that requires many man-hours. Here four men sitting above the shaft keep the lines straight as a new cable is placed onto the shaft hoist. Even though the hole has been covered over, each man is fastened to a safety line.

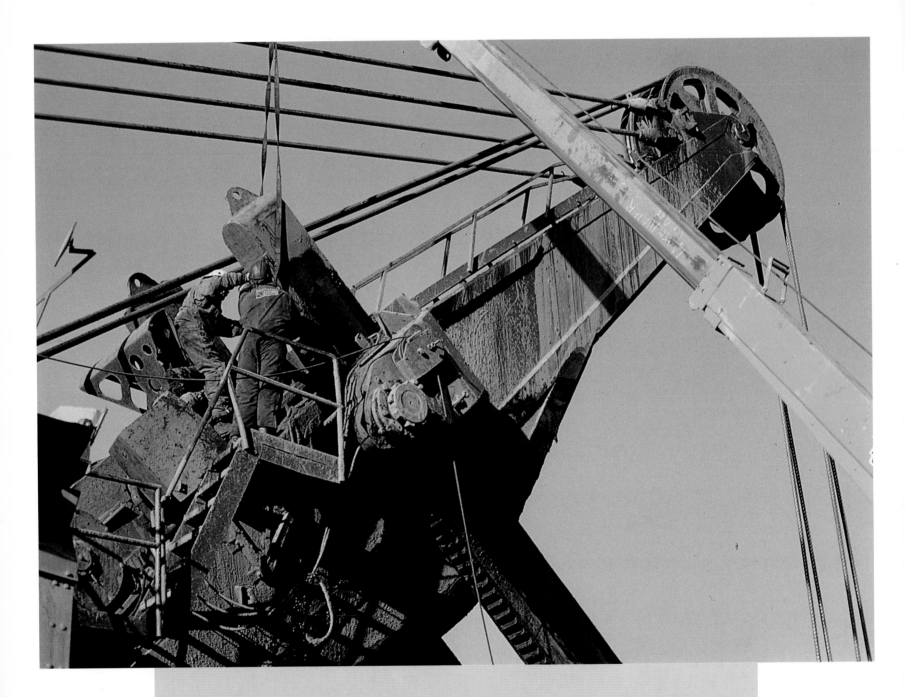

Lester Diamond and Dave Dzus repair a shovel at the Quintette open-pit coal mine.

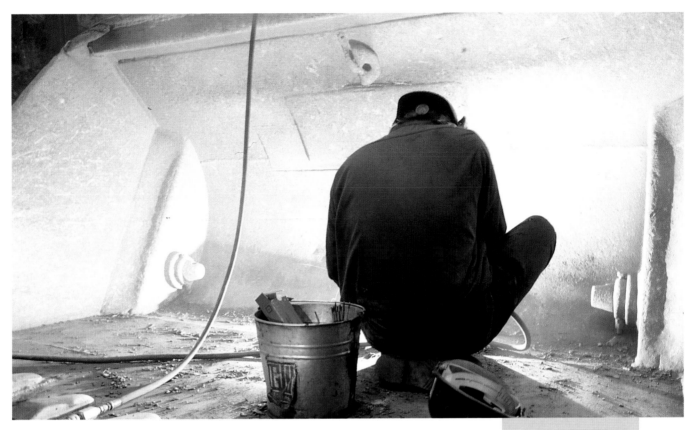

Algoma welder
Robert Tremblay.

requires maintenance crews to work in extreme cold. I remember, soon after a December arrival in Labrador, watching a crew change the main side frames on an electric shovel. The shovel sat at the crest of a hill from which one could see for some 20 kilometres to the northwest. The crew was directly exposed to the prevailing winter winds, which forced them to retreat to their waiting trucks every twenty minutes to warm up.

The workplace for underground mine maintenance crews is not typical of most industrial environments. In underground mines, equipment is sometimes captive in the stopes, leaving mechanics very little room to work. However, the maintenance facilities in underground mines are gen-

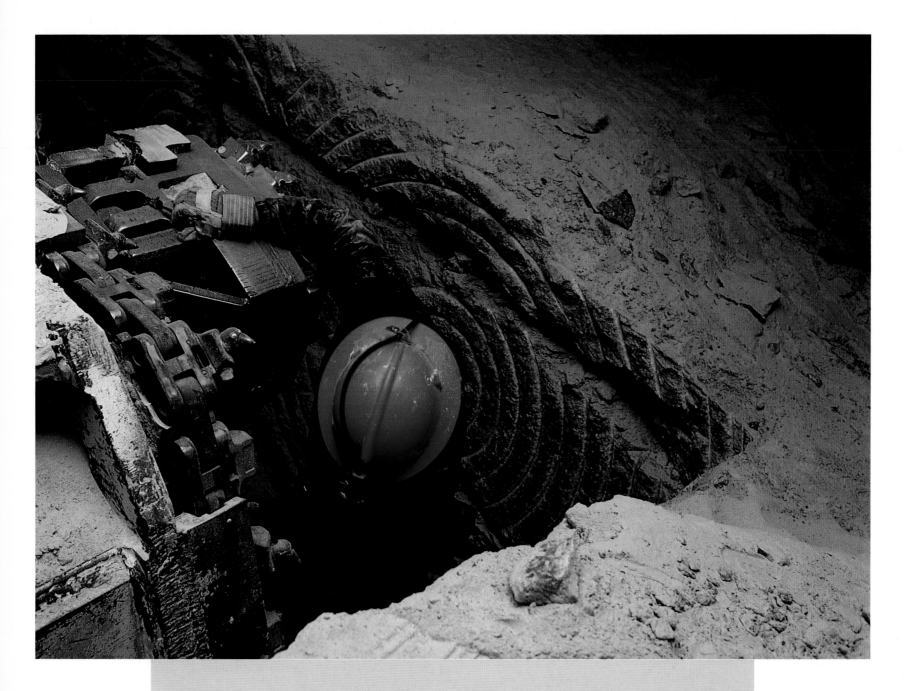

Wade Peterson greasing the boring machine at Lanigan Mine.

erally well developed. Repair areas are excavated, supported by rockbolts, sprayed by concrete, and brightly lit. They are equipped with overhead cranes and other facilities typical of surface repair shops. There are special dangers associated with the use and storage of oils and lubricants underground, so these areas must be well ventilated and equipped with fire-suppression systems. They are also equipped with inventory-storage facilities and computerized maintenance-planning systems.

As the complexity of equipment has increased, so has the complexity of repair procedures. Only twenty years ago the "drill doctor" still made repairs to the hand-held underground drills in a small cluttered shop cut out of the rock. With the introduction of hydraulic drills, the high-pressure filters and pumps demanded almost sanitary facilities to ensure that no contamination of the hydraulic fluids occurred. Today much of the underground equipment is fitted with remote sensors that measure their performance. This information is transmitted to a central facility on surface. In an underground repair situation, advance knowledge of the failure allows the mechanic to prepare the proper tools and parts before proceeding to the repair site.

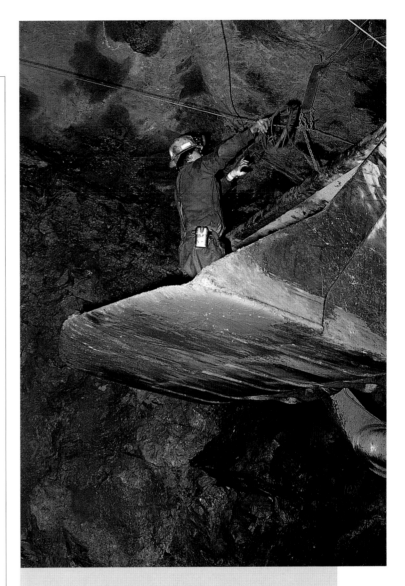

The lines that hold the vent ducting often need repair. Here, Bob Wright at the Equity Silver Mine moves some support cables.

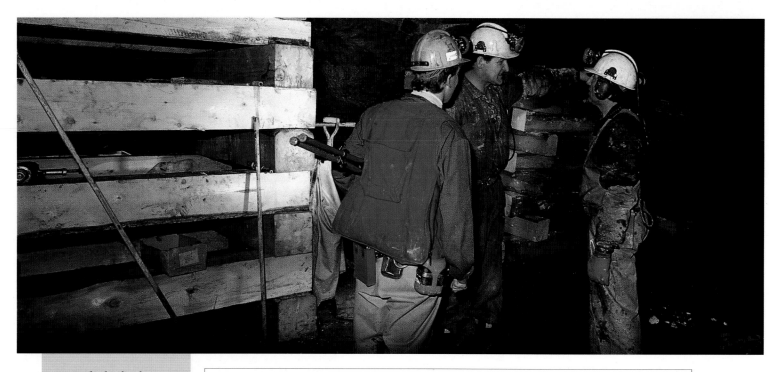

Cribs built along tunnel walls provide an extra measure of support and safety. Steve Kolesar, Dennis Buchberger and Jim Whittacker, at the Golden Bear Mine, discuss how to proceed.

One historical problem in underground mines has been a separation of maintenance and operating crews. Operators often participated in bonus programs while mechanics did not. Many operations now provide skills to equipment operators so that they may make some basic repairs to their machines. This is a small step toward developing the kind of overall skilled tradesperson that will be required to operate the mines of the future.

Preventive maintenance programs are becoming increasingly important. In larger, open-pit equipment, many critical functions are monitored by sensors. Vibration measurement and analysis indicate when bearing systems are becoming worn. By detecting the presence of trace amounts of metals specific to particular bearings, engine-oil analysis can be used to determine exactly which bearings are wearing down. This information can be transferred to a computer database to help in preventive-maintenance planning.

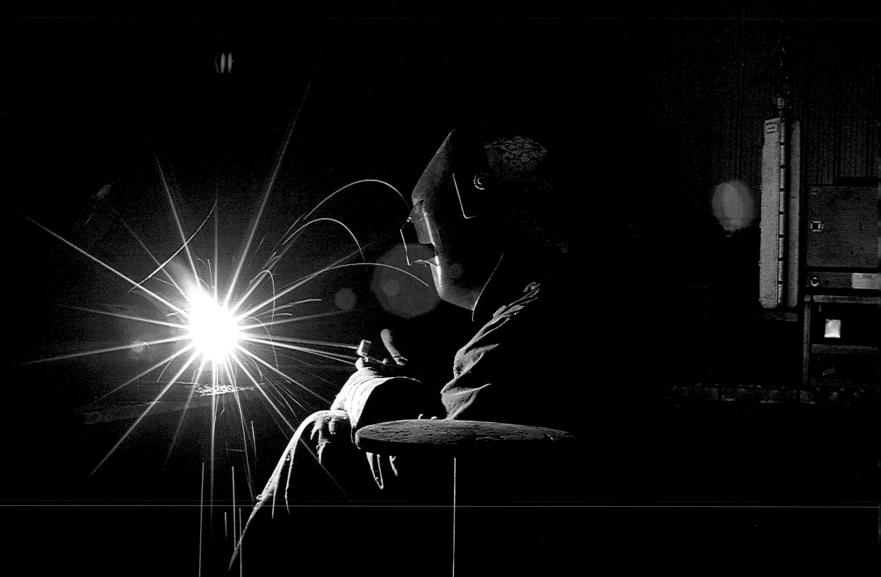

Maintenance crew members like welder Ashley Brett are an indispensible part of any mine team.

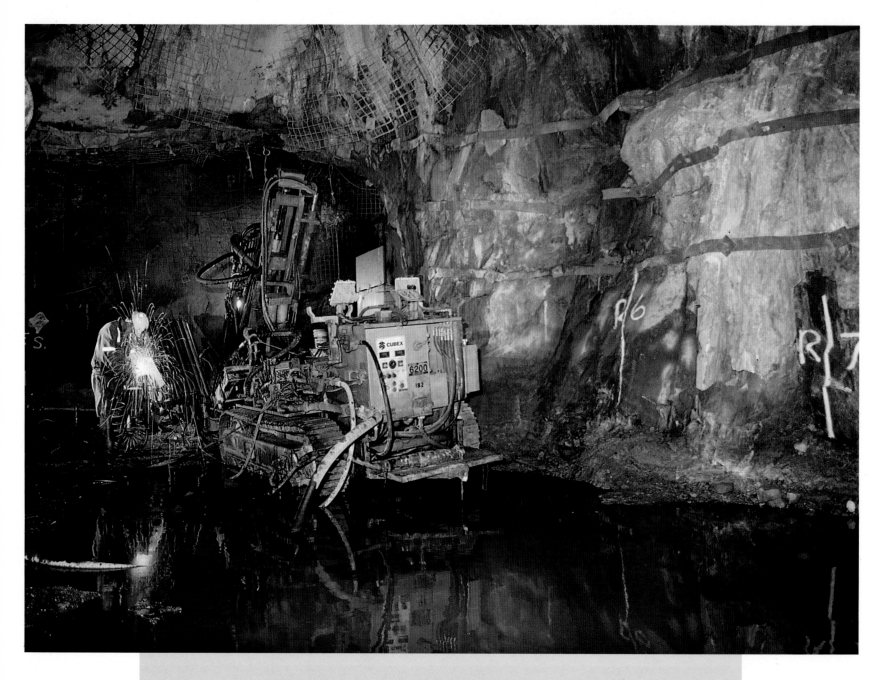

Roy Rochon sharpens the drill bits for reuse at the Golden Giant Mine.

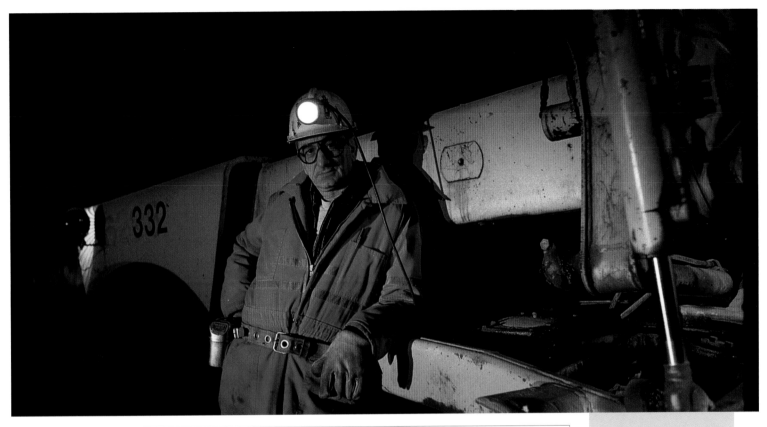

The provision of quality maintenance programs begins with well-trained people. These personnel now have to deal with computerized maintenance-planning systems and with total productive-maintenance systems. Most large mining operations have internal training departments and active apprentice training programs, often in conjunction with local colleges. In Fort McMurray, for example, Keyano Collage is equipped with major mechanical systems to train workers for the large tar-sands operations found nearby. Increased mechanization and automation will require more of these extensive training programs to provide the skilled tradespeople who will be needed to maintain the mines of the future.

Polaris Mine grader-operator Jim Stamp keeps the underground roads smooth and free of debris.

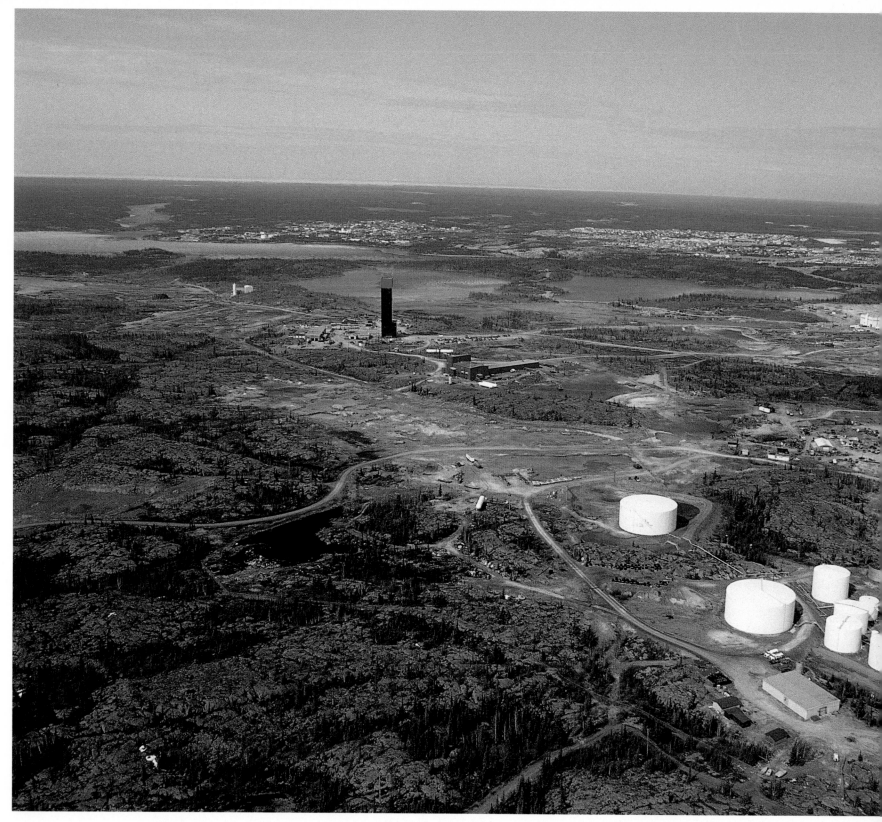

Yellowknife, a town that began with mining, has grown up between two major mines, the Giant and the Con.

CHAPTER NINE

MINING TOWNS
A CHANGING PHILOSOPHY

The early history of the mining industry shows that mines and mining areas developed gradually without the massive infusion of capital that is required in today's investment environment. Production levels were much lower, thus less infrastructure support was required and deposits lasted longer. Small towns grew up around many of these operations, but many of the people were relocated to new company operations as the deposits were depleted. As investment increased, the required infrastructure increased, as did the size of the mining towns. But now the deposits were being depleted at a much faster rate. Unfortunately this led to the decline of many towns. As the economic basis ceased to exist, social support was required as people gradually resettled or found alternate employment.

A striking example of this is Uranium City, Saskatchewan. The prospects for the town, based on the high uranium prices of the late 1970s, were such that the town expanded, including the construction of a modern townhouse development. With the collapse of uranium prices due to the increased availability from the high-grade deposits of the Eastern Athabasca Basin, mining operations in the town ceased. The townhouses have since been totally destroyed along with most of the other buildings in the town. People who continue to live there have retreated to a central core area, which houses the remaining businesses.

Other towns, including Gagnon, Quebec, have completely disappeared. When the Lac Jannine iron-ore pit was depleted and operations from Fire Lake were consolidated at Mount Wright, the Quebec Cartier Mining Corportation decided to totally eliminate the town. All of

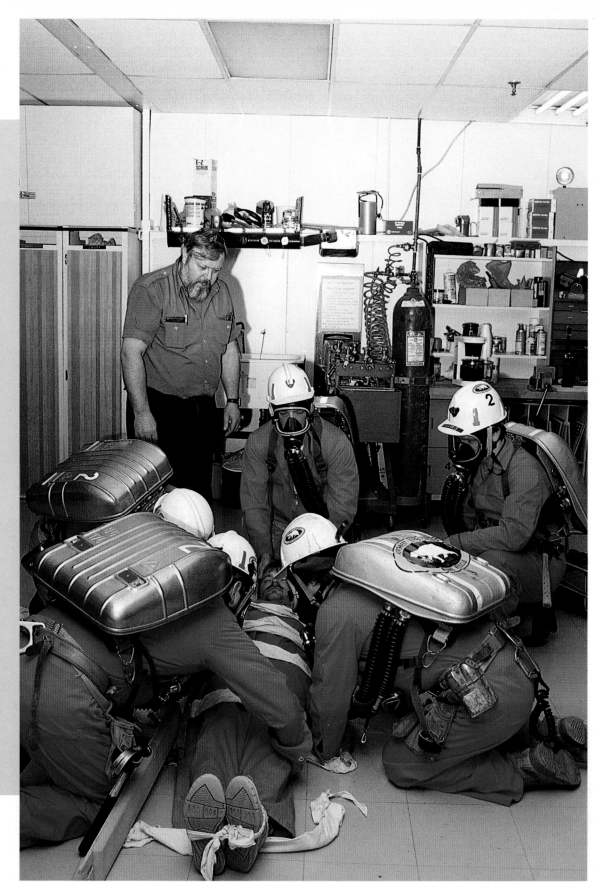

The Polaris Mine rescue team holds regular practices to keep their skills fresh and up-to-date. Though Polaris has a full-time nurse on duty, the nearest medical facility is at least a one-and-a-half hour flight away.

the buildings were pushed into their foundations and the area was regraded. While this seemed a severe decision at the time, it was the best solution. I was with the Iron Ore Company of Canada when the Schefferville operations ceased. I witnessed the rapid decline of abandoned buildings in that harsh climate. During the first unheated winter the foundations cracked, during the next summer the basements flooded, and by the end of the second next winter the foundations were completely destroyed. A large aboriginal population and people involved in the hunting and fishing-based tourism industry remained in the Schefferville area. The company was eventually forced to destroy the houses to reduce the risk of injury to people who might have wandered onto the properties. The Schefferville area is still serviced by rail and has abundant hydro-electricity from the Menihek Dam, making it a potential site for further mineral development as exploration continues in the area.

A more positive story comes from Elliot Lake, where the only operating mine is scheduled to close in 1996. The town had gone through one boom and bust cycle with a boom in the 1950s and a total collapse in the 1960s. The high uranium prices of the 1980s saw a major rise in residential construction. The town has taken advantage of the highly developed infrastructure and the natural beauty of the area and has created a retirement community. People can sell their homes in the more populous areas of Southern Ontario and buy a house in Elliot Lake for a fraction of the money. The extra cash can then go to support a more comfortable lifestyle, including a possible winter trip to warmer southern climes. In addition, funds are available from Ontario Hydro to encourage the development of secondary industry. People are now optimistic about the town's future.

With the abandonment of many mining towns, it became evident that the continuation of mining-based town development was not justified. Transportation infrastructure, however, continues to be essential. In iron-ore mining, for example, approximately thirty percent of the volume mined is shipped as product. The low value of this product demands that transportation to large ocean-going vessels for export be extremely cost effective. Mines producing base-

metal concentrates still require bulk transportation in order to be economical. The Isok Lake property of Metall Limited in Nunavut was recently placed on hold as the cost of providing access to port facilities on Hudson's Bay was too high. The company is awaiting the possible future development of infrastructure in the area.

A change in philosophy began with the development of Arctic-based metal producers immediately adjacent to tidewater in that no townsite was built for these mines. The first of these producers was Cominco's Black Angel Mine in Greenland, which was followed by the Nanisivik Mine on Baffin Island and by the Polaris Mine on Little Cornwallis Island. The Asbestos Hill Mine of Asbestos Corporation in Northern Ungava operated in the same way, with concentrates shipped to a mill in Germany. For each of these mines, construction materials were brought in by boat. In fact, the Polaris mill was constructed in Sorel, Quebec, and floated into place. Operating supplies are brought in during the short shipping season and the concentrate is brought out.

This trend has continued with the development of gold mines such as the Lupin Mine of Echo Bay Mines Limited. With a gold mine, the personnel and short-term supplies can be flown in and the final product flown out. The heavy construction materials and operating supplies such as fuel are brought in over winter roads.

At these locations, modern quarters provide comfort for the crews, who rotate into the operations for limited periods (generally on a ten-week basis for the northern sites and on a weekly basis for more southern operations). Personnel are either rotated back to their homes throughout Canada or to a central major city, depending on the rotation time.

The largest present user of this "fly-in, fly-out" approach is the Saskatchewan uranium industry. Operations such as Rabbit Lake, Cluff Lake and Key Lake contract weekly flight schedules from the major cities in the south as well as from many small communities from Uranium City to Stony Rapids along Lake Athabasca and in the Western Athabasca Basin. Personnel are rotated in on a weekly basis and live in modern accommodations complete with recreational facilities.

Mining has produced many
spin-off enterprises.
Air charter companies
have found a big customer
in the mining industry.

Norman Rivera rows back to the Golden Patricia camp dock after an evening of fishing.
The mine has a collection of boats available for employees to use during their timeoff at the camp.

The rewards for working under these arrangements are high. In 1992, according to Statistics Canada, people living in Polaris on Little Cornwallis Island had the highest Canadian median income, at $92,800, five times the national average of $18,600. Forty-two percent of the residents, mainly men, had an income higher than $100,000. The female occupants of the town had a median income of $39,400. As an added advantage, these people have up to four months' vacation and are provided with food, lodging and transportation. Such high compensation results in low turnover and a long list of job applicants. By 1993, the median income in Polaris had risen to $108,300. Nanisivic followed at $105,400. But that year they were both surpassed by Rockcliffe in Ottawa, home to senior diplomats, civil servants and computer software developers. The top-ten list also included the more traditional mining communities of Yellowknife, the Northwest Territories, and Fort McMurray, Alberta.

One could consider the employment of aboriginal people in the mining industry as a way to minimizing the number of people who

Pride in their industry and concern that the public image of mining is distorted has prompted some mining communities to set up mining museums. It is their hope that increased knowledge of the mining industry will help repair the tarnished image of the past. Pictured here is a bronzed statue in the Murdochville Mining Museum.

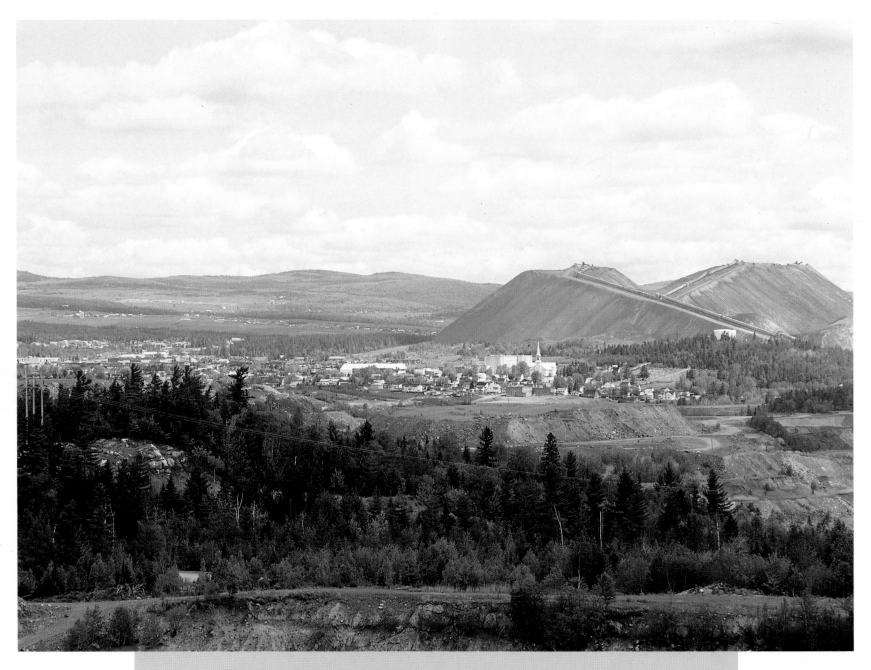

The Black Lake Mine is surrounded by homes. The houses have been constructed as close to the minesite as possible, leaving little room for the mine to grow.

have to be transported long distances to mining sites. Unfortunately, the size of most existing aboriginal communities would not provide an adequate employee base and relocating more aboriginal people to the area would put too much strain on the fish and game that support their fishing and hunting. The biggest limitation to their participation, however, has been a lack of skills and management training among northern aboriginals. In Saskatchewan, the goal is for fifty percent participation by people from the North, although the definition of a northerner is somewhat controversial, including non-aboriginals who live in Uranium City, for example, or aboriginals who have relocated to the south.

In fact, before an environmental review panel examining the future of Uranium mining in Saskatchewan, aboriginal people had divided opinions about their participation in fly-in operations. While many said it gave them the opportunity to participate in their traditional activities, some also stated that they were treated differently by their peers upon returning home to their Native communities, particularly because they now had a higher level of disposable income than their peers. Many of the Native women found it quite difficult to cope in the absence of their husbands, especially during the severe winter months. The number of Natives who had relocated to southern communities where better educational and health facilities were available to their families was also quite significant.

The fly-in, fly-out system has allowed the smaller deposits of the North to be mined without the high cost of infrastructure development. People who participate in the program are able to take advantage of high incomes and their families can still enjoy the comforts of life in the south. The system allows participation in the mining industry by aboriginal peoples and eliminates the social relocation costs associated with abandoned mining communities. It is a system here to stay for those mines that can be exploited without major land-based transportation links.

These mined-out areas at the Cluff Lake Mine have been recontoured and revegetated, restoring them to near pre-mining conditions.

MINING AND THE ENVIRONMENT

The World Wildlife Fund ran a full-page advertisement in the June 27, 1994, edition of *Maclean's* magazine proclaiming that Canada loses 240 acres of wilderness every hour. The advertisement began, "in the minute it takes you to read this page, over 4 acres of Canadian Wilderness will be lost to logging, roads, railways, subdivisions and agriculture." Notice that mining was not included in the list. Those of us who make a living in the mining industry often feel that we are unjustifiably singled out as environmentally insensitive. Perhaps attention is focussed on the industry because it is so easy to isolate the remote mining site from the collective "economic development" that pollutes the more developed areas of the country. Perhaps the great personal wealth that can be generated from mining creates the public opinion that mining has only a profit motive.

There is no doubt that the mining industry has been responsible for environmental damage. The main problem originates from abandoned tailings ponds that contain sulphide minerals. These ponds are now generating acid-bearing solutions that contaminate water supplies. Many of these sites have been abandoned by their original operators

The rehabilitation of the massive ponds of uranium tailings that exist in Elliot Lake are now the subject of a federal environmental review. Clean-up costs have been estimated at as high as one hundred million dollars. The companies that operated in the area are contributing limited funds to the clean-up, but the remainder will have to come from the taxpayer.

In one recent example, a beaver dam broke under spring flood conditions, causing an old

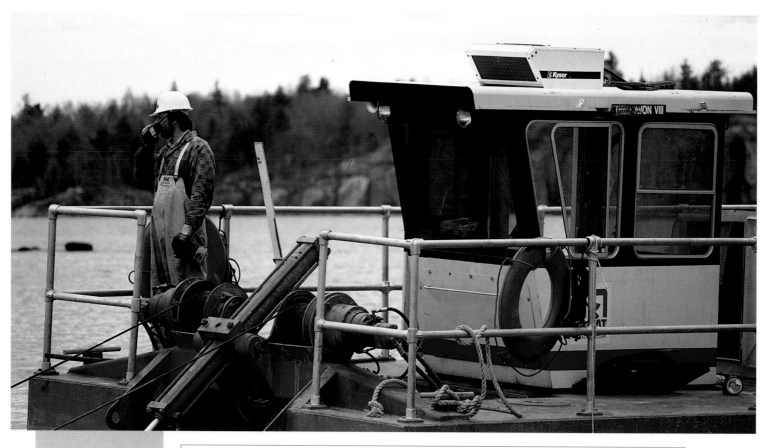

Gary Schram runs a dredge in an effort to clean up old tailings ponds at Elliot Lake.

tailings dam at a long-abandoned gold mine to rupture and spill a significant volume of tailings into Ontario's Montreal River. The present owners acquired the property to assess the potential of removing gold still contained in the stored tailings as a result of the inefficient early milling processes. The Ontario government has held the new owners liable for the environmental damage. The present owners argue that they should not be responsible for the actions of the previous owners. Reopening these old waste dumps to retrieve the remaining ore is one of the possible solutions for making these sites more environmentally secure. Ironically, though, the environmental liability of such properties often prevents companies from acquiring them.

There are also examples of conscientious efforts to mitigate environmental damage. The mining and milling sites of what is now Cameco have been extensively restored and are being reclaimed by the forest. The tailings in the dam have been covered and are monitored on a regular basis. In fact, surface disposal of uranium tailings as carried out in Elliot Lake and Uranium City is no longer permitted. The "pervious surround" disposal system developed at Rabbit Lake, which utilizes the mined-out pit from the initial orebody and isolates the tailings from both surface and groundwater flow, has become the standard disposal method.

An Insitu fish bioassay experiment is being conducted by David McHaina
at the Arthur White Mine control weir as part of tailings management strategies.

What should be done to prevent environmental mismanagement in the future? The problem will not be solved by introducing an unrealistic spate of new environmental regulations. Governmental legislators must ensure controlled and sustainable development through regulations that are adequate to protect the environment but not overly restrictive. The solutions must be based on scientific fact, and not political motivation. Regulators should demand that a decommissioning plan exist for a mining operation before approval is given. They should also ensure that private funding will continue to be in place to ensure that decommissioning is carried out should the company suffer economic losses. This could be achieved through environmental bonding. Unfortunately these solutions may make mine development economically unattractive.

The current environmental regulations in this country have been blamed by some for the flight of Canadian mining investment capital to other countries. This does not mean that guidelines do not have to be followed in other countries. In fact, the modern multinational mining company is committed to meeting sound environmental guidelines in any new mining investment. The guidelines imposed by the strictest jurisdictions become standard for design guidelines of plants built in developing countries with less stringent environmental regulations. For example, I recently visited a Canadian-owned gold mine under construction in Panama where the leach pad was designed to California standards because that was the design standard adopted by the American construction manager. Projects funded by the World Bank and by the Canadian agencies CIDA and IDRC are looking into the environmental damage caused by the small artisanal miners in many developing countries and examining ways to introduce the improved technology that has become the standard for larger operations. The main demands of large investors are that the approval process be well defined and timely and that the standards not be changed arbitrarily.

In Canada some difficulty in getting environmental approval stems from the jurisdictional overlap that occurs between the federal and provincial governments, making definitive inter-

pretation of the rules difficult. This increases the time required to carry out the environmental review of new projects. While public input into the review process is necessary and admirable, too much attention is given to special-interest groups whose main objective is to delay the process. The process becomes more important than the provision of a well-informed decision. Government agencies, undergoing deep cuts in spending, are being forced to focus too much on such reviews and not enough on the basic research required to develop reliable environmental guidelines. For example, a review of the Saskatchewan uranium mining industry will focus on whether the Saskatchewan Surface Water Quality Guidelines are being met by liquid effluent from the mines. These guidelines were developed to control the quality of water farmers used to irrigate wheat and have little to do with the effects of effluent from a uranium mine on the ecosystem of a lake. Environment Canada should be using its scientists to study these effects instead of sitting through months of hearings. Industry should be directing its efforts toward developing better and more efficient milling technology for uranium ores rather than attempting to prove that they can meet irrelevant twenty-year-old regulations.

One misrepresentation about the mining industry is that there is a very high incidence of occupational disease. There is no question that in the early days there was a high incidence of silicosis among gold miners, a problem now prevented by proper dust control. There has been much publicity about the dangers of exposure to asbestos to the point that it has been removed from public buildings, even though the removal process is probably more dangerous than leaving it in place. Both the advantage and the problem with asbestos is that it is an inert substance occurring a fibrous form. As a replacement we have substituted fibreglass, a fibrous form of silica. Since it takes in excess of twenty years for exposure to asbestos to show up as a health problem, it should not be surprising if problems appear from exposure to fibreglass.

As far as accident frequency is concerned, according to figures compiled over the past decade by the Mining Association of Canada, mining had less fatalities than construction, manufacturing and transportation. In terms of fatalities, the rate in mining was higher than

Rocanville potash mine tailings pond holds all the liquid waste left over from the milling process.

Environmental concerns are highly visible on the Syncrude property. As well as restoring the surface areas with grass and trees, the mine has worked out a program to build a herd of bison that will eventually be turned out onto the reclaimed areas. They have also encouraged Native involvement, with local Native bands acting as major caretakers of the bison herd, tree planting and greenhouse operations.

those industries but lower than the forestry industry. Figures show that mining fits into the pattern of Canadian industry.

Of course we cannot ignore tragedies such as the disaster at Westray, where in May, 1992, a spark initiated a methane and coal-dust explosion. Twenty-six workers were killed and damage to the mine was so extensive that rescue workers had to abandon their efforts to recover eleven remaining bodies. The court cases and inquiries originating from that incident are still ongoing, and surviving relatives feel that justice has

not been served. The company that operated that mine is now in bankruptcy. The incident at Westray rightfully produces a negative attitude among the public. The modern mine must be well designed and operated so as to prevent such accidents. But we are dealing with an imperfect medium, and quite often with human error. The close public scrutiny focused on the mining industry should help to ensure that the best efforts are being put forward to eliminate industrial accidents in the future.

Environmental damage has been caused by many industries. While this does not excuse the mining industry, the bulk of the damage caused directly by mining occurred early in the history of the industry, when environmental standards and technology were not as high as today. An advertising campaign done by Caterpillar a few years ago carried the caption, "there are no simple solutions, only intelligent choices." As Canadians we must make these kinds of choices. For economic growth to occur, changes in the environment are necessary. The contribution that mining makes to the Canadian economy more than justifies the closely controlled environmental disruption caused by modern mining operations. Development ought to be sustainable, however, and changes to the environment by industries utilizing non-renewable resources must be minimal and reversible.

We should not be proud of the environmental and occupational-health history of the mining industry. On the other hand we should not let history detract from the fact that present industry standards meet the strictest environmental-control regulations. Problems will not be solved by government alone. Some of the worse polluters in Canada are provincially controlled power corporations and municipal sewage disposal systems. Intelligent choices must be made based on well-researched facts and not on special interest campaigns. The leaders of the mining industry have come to realize that future development must be sustainable and responsible.

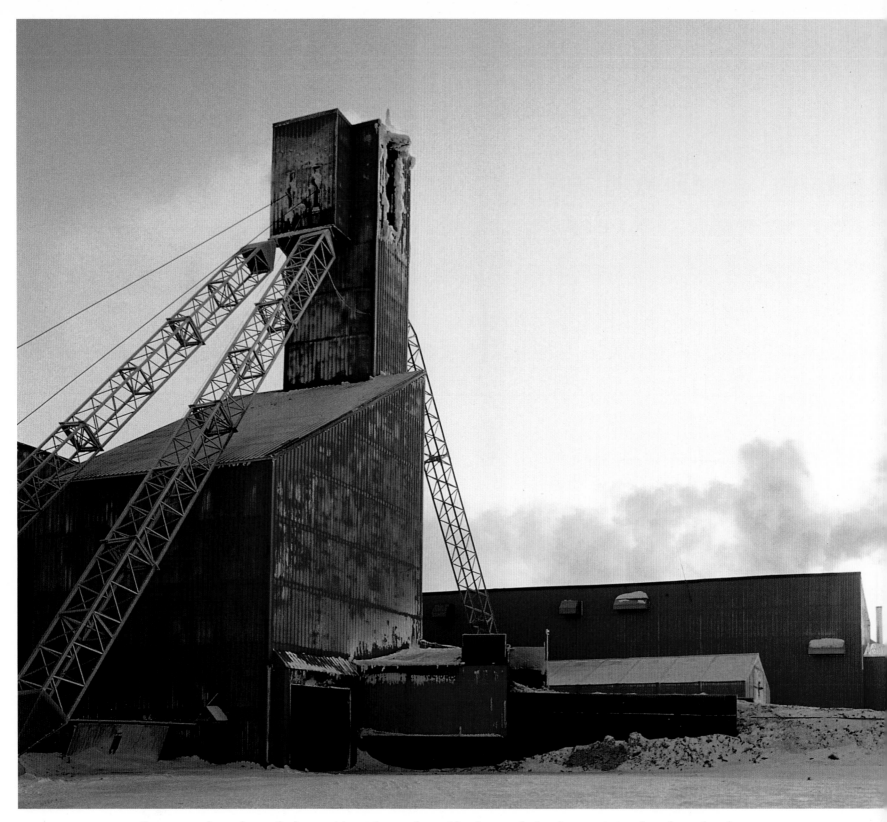

Ore reserves located near the larger cities and towns have either become depleted or restrictions have been placed on the locations to prohibit mining. Mines in the future will be found in more remote locations. The Echo Bay Mine, high up on the tundra in the Northwest Territories, can only be reached by plane or winter ice roads.

THE FUTURE

M any people describe mining as a sunset industry, and government legislators develop policies to encourage the high-tech industries. There is no doubt that the export of components and support for those technologies to developing countries will be important to Canada's future. Internally, however, a sound economy will be dependent on the use of these technologies in primary industries such as mining, forestry and manufacturing.

One certainty is that there will be continued demand for metals and mineral products. This demand is constantly changing. The demand for lead, for example, has declined to the point that its presence in an orebody is more an environmental problem than an economic benefit. Iron and its alloy metals will always be in demand in the steel industry but the demand will likely decline as metal recycling increases. The continued use of stainless steel in the pollution-control devices of the forestry, chemical and manufacturing industries bodes well for nickel consumption, and now for the development of a long-term nickel-mining industry in Labrador. The replacement of copper with aluminum for conductors in domestic buildings has been reversed by long-term safety problems. Uranium remains a viable source of energy. The industrial use of gold is expected to increase. The increased use of cameras in developing countries could greatly increase silver consumption, though newer digital technology may replace the use of conventional silver-based films.

With non-metals, the demand for asbestos has virtually ceased domestically but it is still used in building products in developing countries. The demand for fertilizer and hence for our large potash reserves will continue as the world population increases. Coal remains a necessity for the metallurgical industry and a viable source of energy. The discovery of gem-quality

*At the Golden Patricia Mine, Lucien Girard relaxes outside the exercise building
a short distance from the main camp.*

diamonds in Canada will likely lead to viable mining operations. In addition the development of a viable superconductor will probably increase the demand for "space-age" minerals, which now have a limited market. Canada has known reserves of beryllium, niobium, yttrium and heavy rare earths that may someday become economically viable.

There is uncertainty as to whether these minerals will continue to be produced in Canada. Considerable exploration expenditures are being made in South America, Africa, the Commonwealth of Independent States, and Eastern Asia. These countries will provide

During the long winter months at the Polaris Mine, the men experience little daylight. This bit of light at high noon near the end of January, will only last an hour or two.

very competitive alternative sources of many of these mineral products. Continued investment in exploration is required in Canada if mined reserves are to be replaced. Canada has a well-developed infrastructure for secondary and tertiary processing of metals. We have six copper smelters, for example, two of which are already looking to imported concentrates as a source of supply. If the decline in copper concentrate production continues, the continued economic viability of some of these smelters will be in question, particularly as smelting technology advances.

The future of the mining industry in Canada will rely on several factors. The further development of several established mining areas such as the Sudbury mines and Kidd Creek will be dependent on the existence of greater reserves at depth. As depth increases, the rock stress will demand alternative mining techniques. New deposits will likely be found in the more remote and relatively unexplored areas of Canada. Orebodies with complex metallurgy will also require new techniques in order to extract the individual metals economically.

These factors demand that research into new technologies be intensified. Computerized systems are already used extensively in the mining industry in the design of mines, in process control, in open-pit dispatching systems and in equipment monitoring. This technology is now being adopted in the development of automated robotic machinery for use in underground mining.

The industry must accept that environmental regulations will be demanded by society and that as our more environmentally aware youth mature, these regulations will likely become even more stringent. We must realize that there are some areas or deposits that should not be mined, based on valid environmental concerns. The Windy Craggy copper-cobalt deposit in British Columbia, for example, now sits in a newly created provincial park and will not be developed. The owner has been compensated for the exploration funds that went into its discovery. On the other hand, people cannot expect to work in urban industries and have the remaining areas of the country preserved as pristine weekend escapes. Government agencies

Mounting public pressure to clean up old mining areas has most mines carrying on day-to-day clean-up operations as part of their normal routine. Here a loader at the Williams Mine is filling in an entry to the old open-pit section so that it will fill in with water, creating a pleasant lake for future public use.

and special-interest groups must understand that some degree of environmental disruption is necessary to keep urban industry alive.

The Canadian mining industry has a skilled workforce. The use of automated and robotic systems will increase the skill levels demanded of individuals in this workforce. Mines developed in remote locations will likely require fewer employees. Communications technology will allow many administrative and engineering functions to be carried out from a distance as the dispersed office gains acceptance.

Finally, it is hoped that this brief pictorial introduction to the Canadian mining industry and its community will enable readers to better understand the important role of mining in this nation's past, present and future. This will help to ensure that the evolution and development of the industry can continue in a legislative environment based on the demands of an informed public.